THE LEGEND OF KORRA

PATTERNS IN TIME

Created by
BRYAN KONIETZKO
MICHAEL DANTE DiMARTINO

Featuring stories by
JAYD AÏT-KACI
SAM BECK
HEATHER CAMPBELL
DELILAH DAWSON
MICHAEL DANTE DiMARTINO
BLUE DELLIQUANTI
JEN XU AND K. RHODES
KIKU HUGHES
ALEXANDRIA MONIK
KILLIAN NG
RACHEL SILVERSTEIN
LYNETTE WONG
MICHELLE WONG
VICTORIA YING

Cover Art by
SACHIN TENG

DARK HORSE BOOKS

president and publisher **MIKE RICHARDSON**

editor **RACHEL ROBERTS** associate editor **JENNY BLENK** assistant editor **ANASTACIA FERRY**

designer **SARAH TERRY** digital art technician **SAMANTHA HUMMER**

Special thanks to James Salerno and Jeff Whitman at Nickelodeon,
to Michael Dante DiMartino, Bryan Konietzko, and Joan Hilty at
Avatar Studios, and to Dave Marshall at Dark Horse.

Published by **DARK HORSE BOOKS**
A division of Dark Horse Comics LLC
10956 SE Main Street, Milwaukie, OR 97222

DARKHORSE.COM | **NICK.COM**

Comic Shop Locator Service: comicshoplocator.com
First edition: November 2022 | eBook ISBN 978-1-50672-180-4 | ISBN 978-1-50672-186-6

1 3 5 7 9 10 8 6 4 2
Printed in China

MIX
Paper from
responsible sources
FSC® C109093
www.fsc.org

Neil Hankerson Executive Vice President • Tom Weddle Chief Financial Officer • Dale LaFountain
Chief Information Officer • Tim Wiesch Vice President of Licensing • Matt Parkinson Vice President of
Marketing • Vanessa Todd-Holmes Vice President of Production and Scheduling • Mark Bernardi Vice
President of Book Trade and Digital Sales • Randy Lahrman Vice President of Product Development • Ken
Lizzi General Counsel • Dave Marshall Editor in Chief • Davey Estrada Editorial Director • Chris Warner
Senior Books Editor • Cary Grazzini Director of Specialty Projects • Lia Ribacchi Art Director • Matt Dryer
Director of Digital Art and Prepress • Michael Gombos Senior Director of Licensed Publications • Kari
Yadro Director of Custom Programs • Kari Torson Director of International Licensing

NICKELODEON THE LEGEND OF KORRA™: PATTERNS IN TIME

Library of Congress Cataloging-in-Publication Data

Names: Konietzko, Bryan, creator. | DiMartino, Michael Dante, writer. |
 Aït-Kaci, Jayd, illustrator. | Beck, Sam, illustrator. | Campbell,
 Heather (Comic book artist), illustrator. | Teng, Sachin, illustrator.
Title: The legend of Korra : patterns in time / created by Bryan Konietzko,
 Michael Dante DiMartino ; featuring stories by Jayd Aït-Kaci, Sam Beck,
 Heather Campbell [and others] ; cover art by Sachin Teng.
Other titles: Patterns in time | Legend of Korra (Television program)
Description: First edition. | Milwaukie, OR : Dark Horse Books, 2022. |
 Summary: "Join Korra, Asami, Mako, Bolin, Tenzin, and more familiar
 faces from The Legend of Korra, featured in stories specially crafted by
 a bevy of talented comics creators!"-- Provided by publisher.
Identifiers: LCCN 2021055416 (print) | LCCN 2021055417 (ebook) | ISBN
 9781506721866 (trade paperback) | ISBN 9781506721804 (ebook)
Subjects: LCGFT: Fantasy comics. | Graphic novels.
Classification: LCC PN6728.L434 L44 2022 (print) | LCC PN6728.L434
 (ebook) | DDC 741.5/973--dc23/eng/20211227
LC record available at https://lccn.loc.gov/2021055416
LC ebook record available at https://lccn.loc.gov/2021055417

CONTENTS

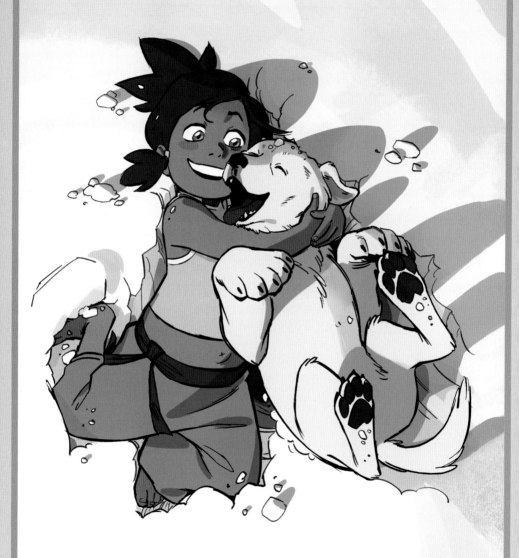

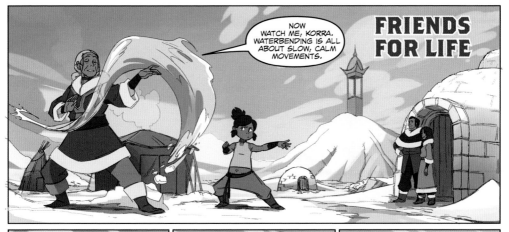

NOW WATCH ME, KORRA. WATERBENDING IS ALL ABOUT SLOW, CALM MOVEMENTS.

FRIENDS FOR LIFE

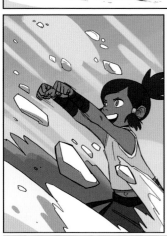

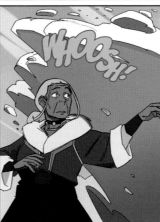

WHOOSH!

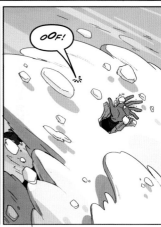

OOF!

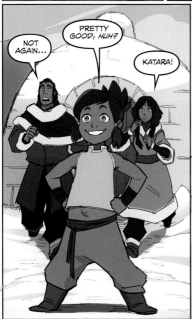

NOT AGAIN...

PRETTY GOOD, HUH?

KATARA!

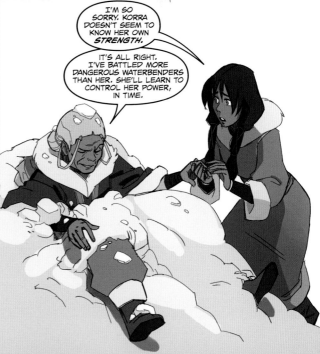

I'M SO SORRY. KORRA DOESN'T SEEM TO KNOW HER OWN STRENGTH.

IT'S ALL RIGHT. I'VE BATTLED MORE DANGEROUS WATERBENDERS THAN HER. SHE'LL LEARN TO CONTROL HER POWER, IN TIME.

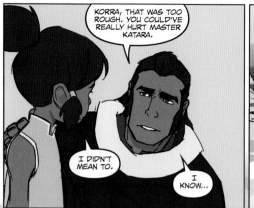

KORRA, THAT WAS TOO ROUGH. YOU COULD'VE REALLY HURT MASTER KATARA.

I DIDN'T MEAN TO.

I KNOW...

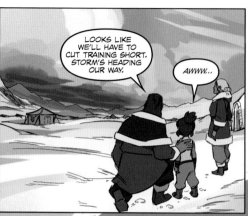

LOOKS LIKE WE'LL HAVE TO CUT TRAINING SHORT. STORM'S HEADING OUR WAY.

AWWW...

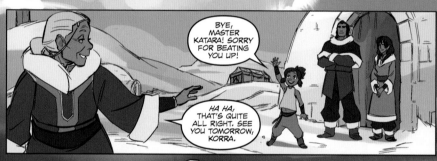

BYE, MASTER KATARA! SORRY FOR BEATING YOU UP!

HA HA, THAT'S QUITE ALL RIGHT. SEE YOU TOMORROW, KORRA.

AAAH-OOOOOH!

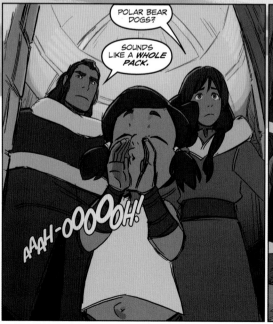

POLAR BEAR DOGS?

SOUNDS LIKE A *WHOLE PACK.*

AAAH-OOOOOH!

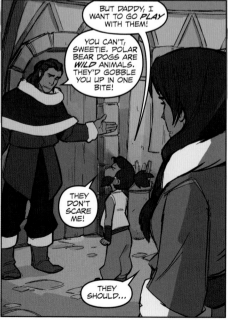

BUT DADDY, I WANT TO GO *PLAY* WITH THEM!

YOU CAN'T, SWEETIE. POLAR BEAR DOGS ARE *WILD* ANIMALS. THEY'D GOBBLE YOU UP IN ONE BITE!

THEY DON'T SCARE ME!

THEY SHOULD...

6

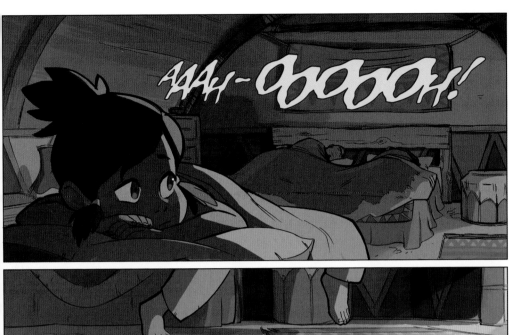

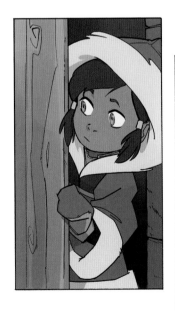

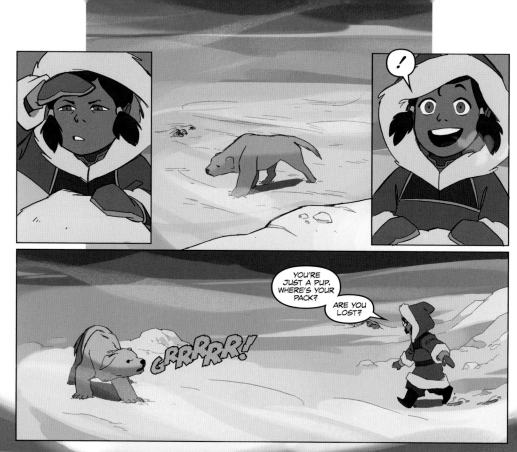

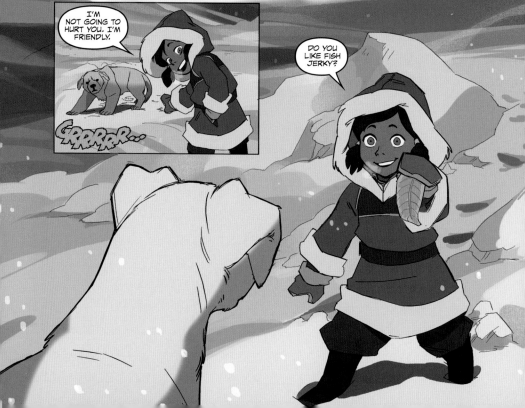

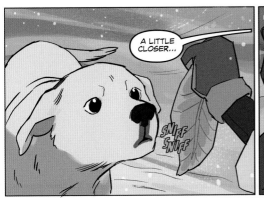

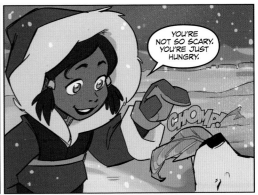

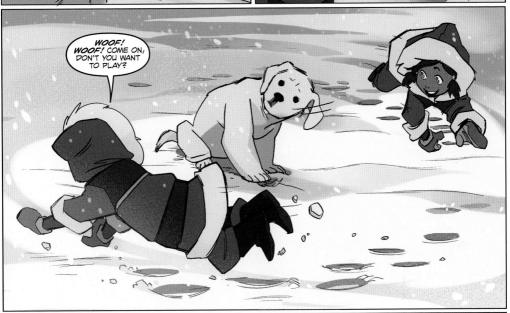

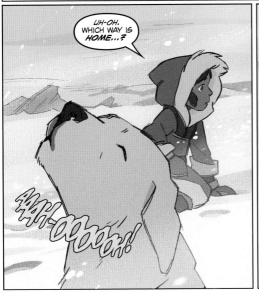

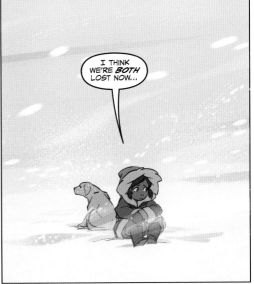

9

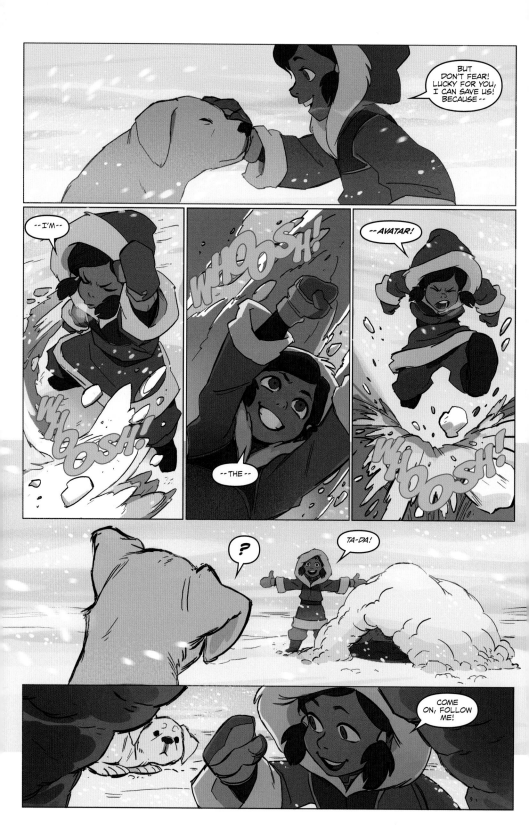

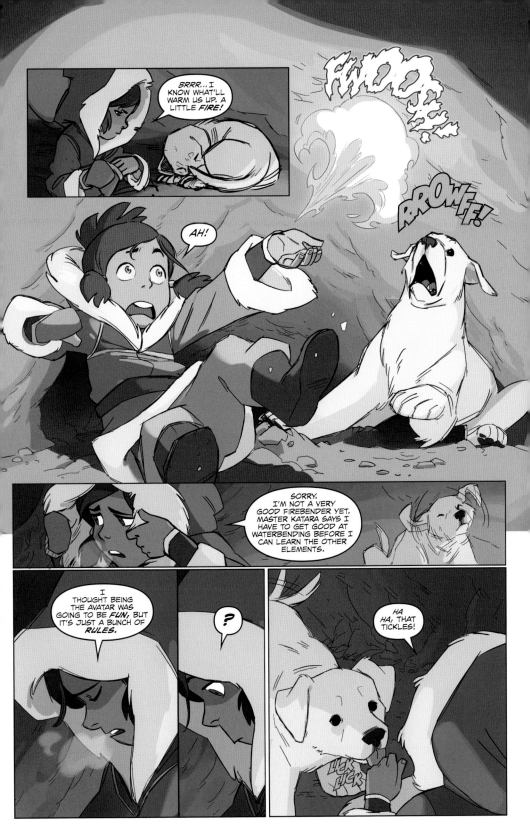

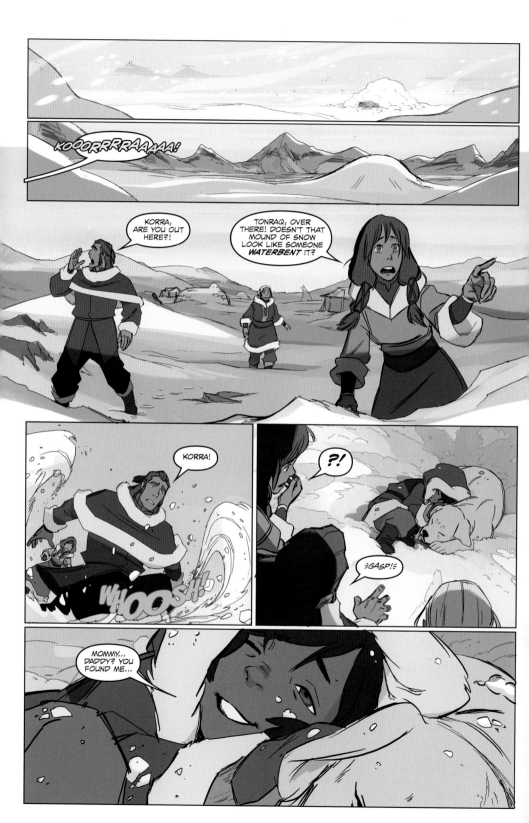

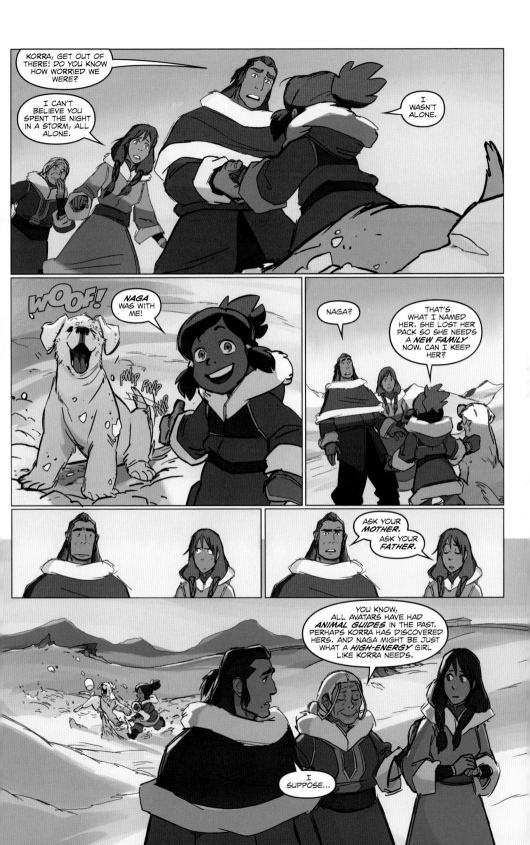

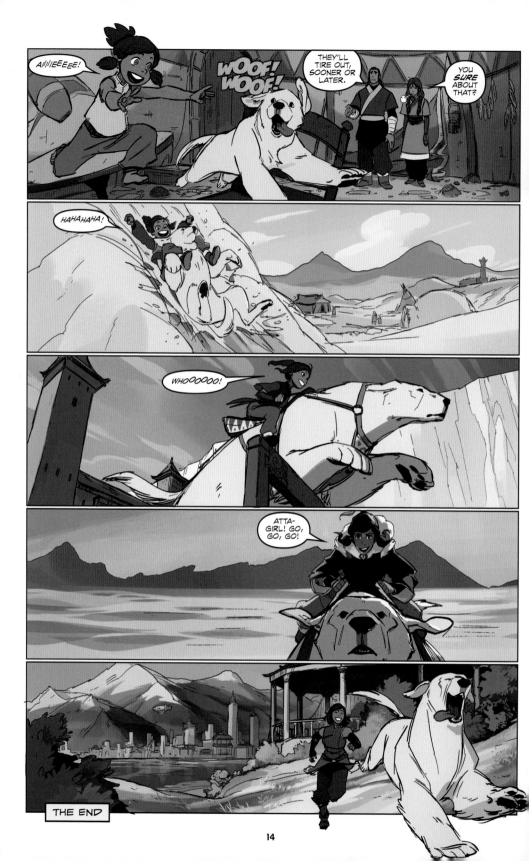

THE END

14

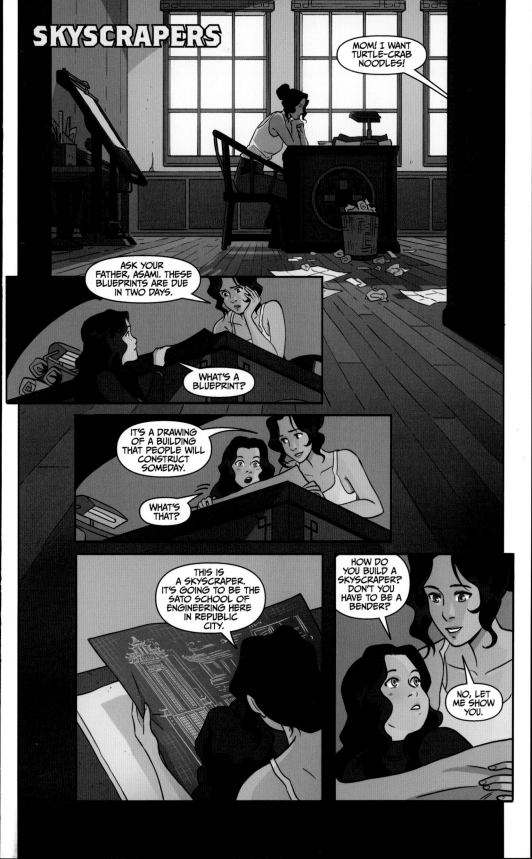

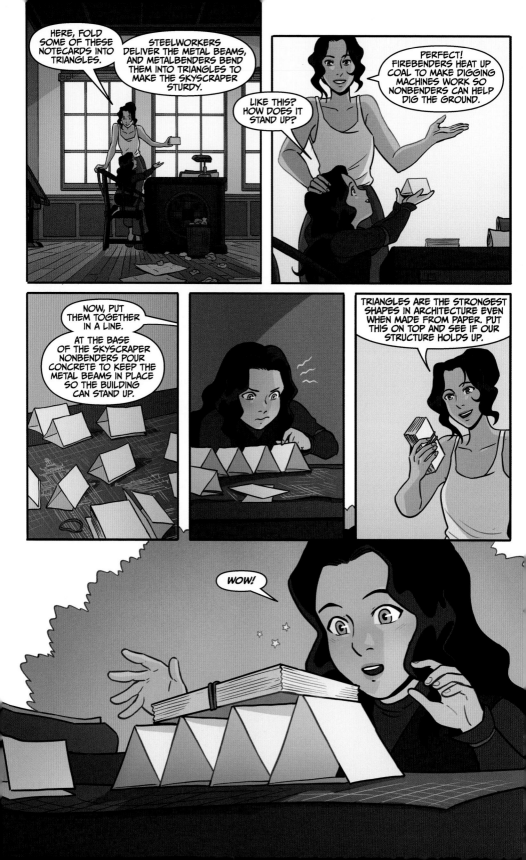

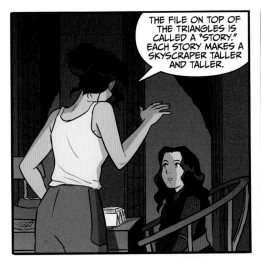

THE FILE ON TOP OF THE TRIANGLES IS CALLED A "STORY." EACH STORY MAKES A SKYSCRAPER TALLER AND TALLER.

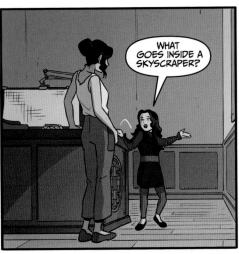

WHAT GOES INSIDE A SKYSCRAPER?

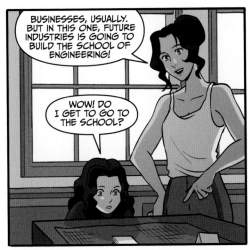

BUSINESSES, USUALLY. BUT IN THIS ONE, FUTURE INDUSTRIES IS GOING TO BUILD THE SCHOOL OF ENGINEERING!

WOW! DO I GET TO GO TO THE SCHOOL?

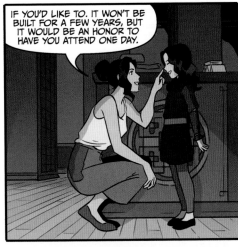

IF YOU'D LIKE TO. IT WON'T BE BUILT FOR A FEW YEARS, BUT IT WOULD BE AN HONOR TO HAVE YOU ATTEND ONE DAY.

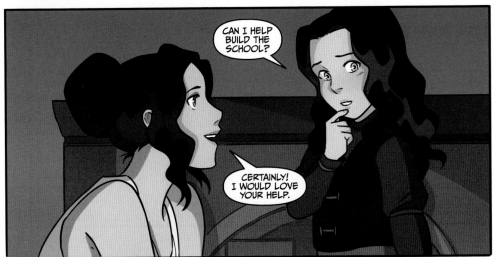

CAN I HELP BUILD THE SCHOOL?

CERTAINLY! I WOULD LOVE YOUR HELP.

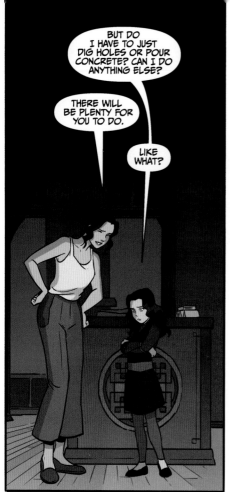

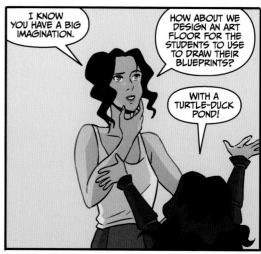

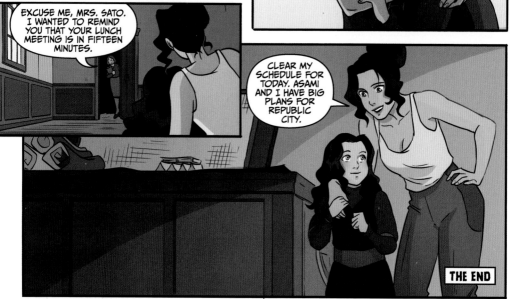

THE END

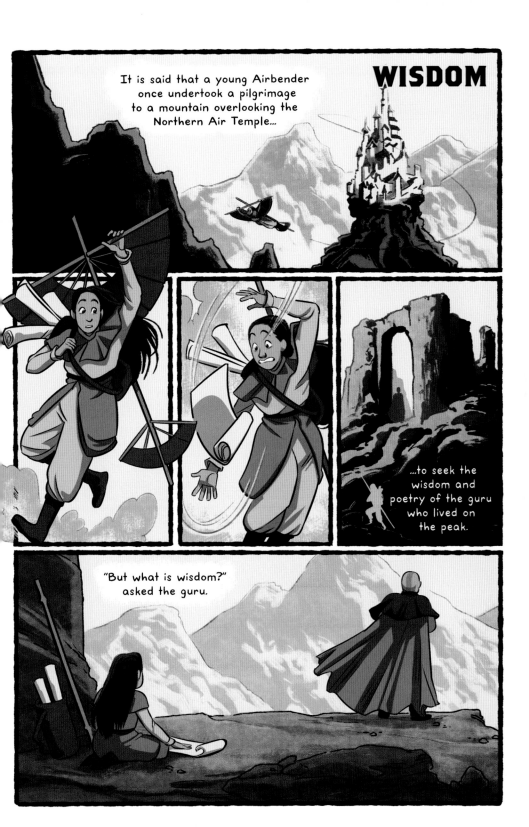

WISDOM

It is said that a young Airbender once undertook a pilgrimage to a mountain overlooking the Northern Air Temple...

...to seek the wisdom and poetry of the guru who lived on the peak.

"But what is wisdom?" asked the guru.

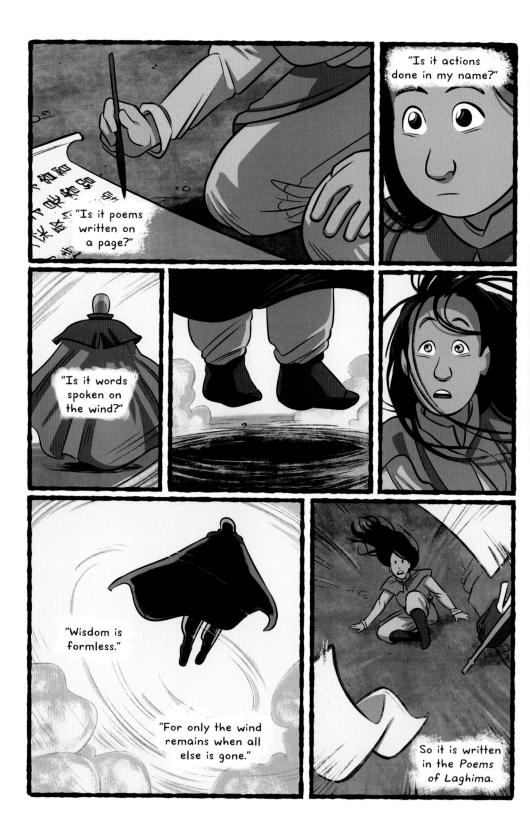

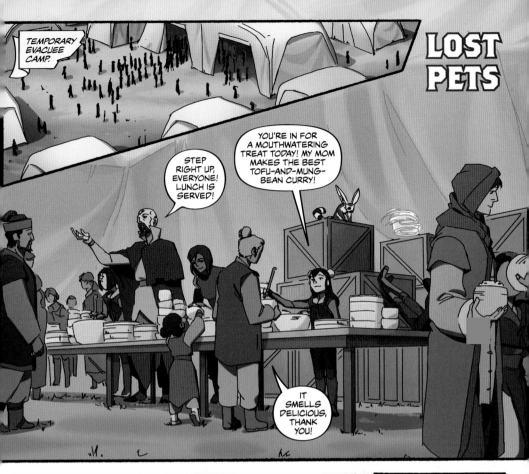

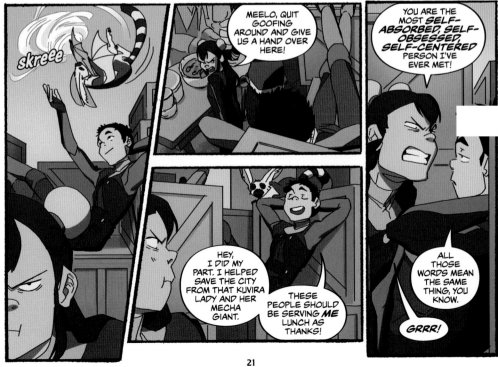

21

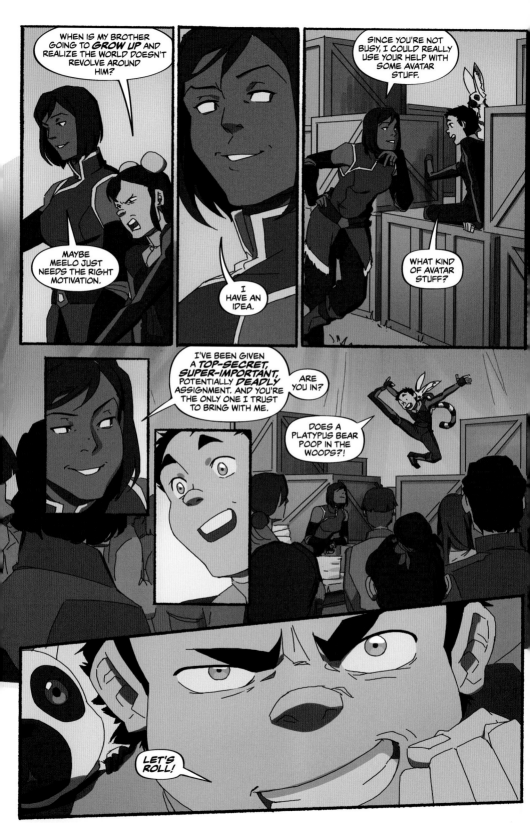

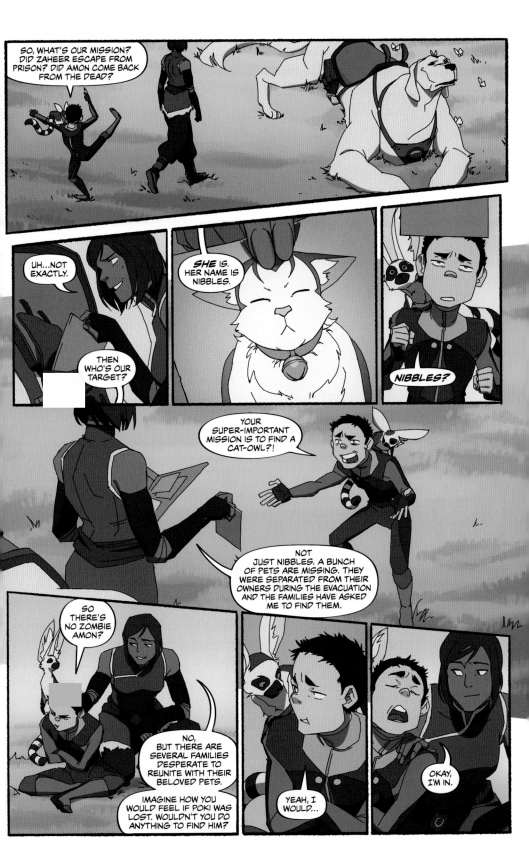

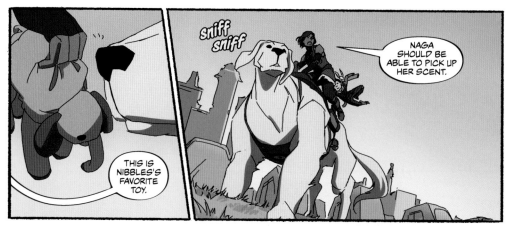

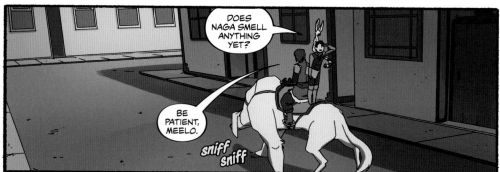

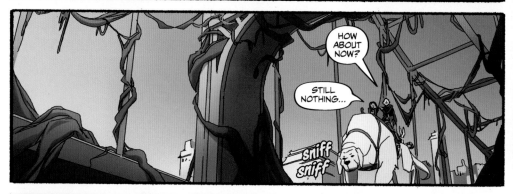

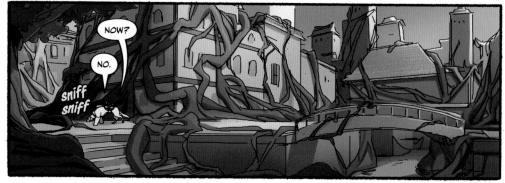

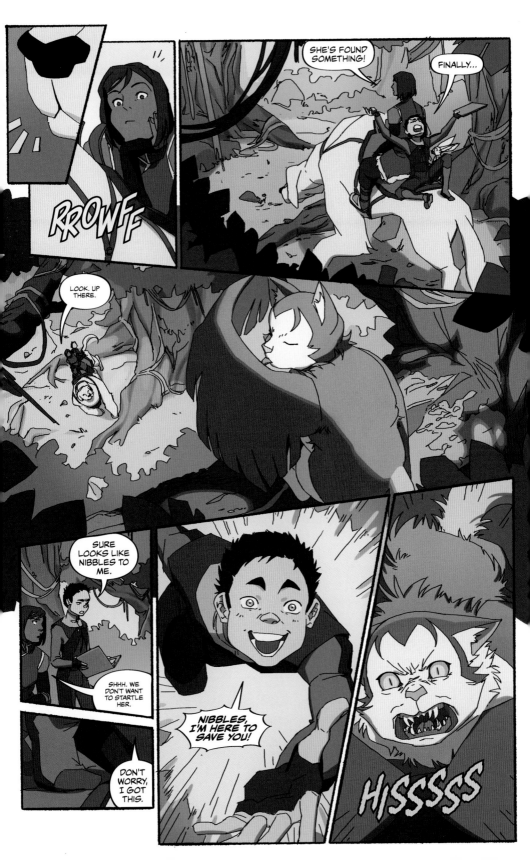

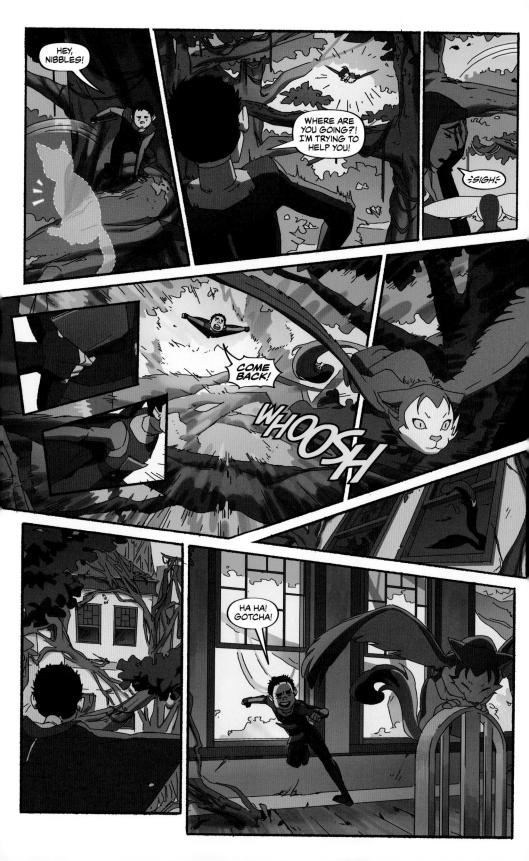

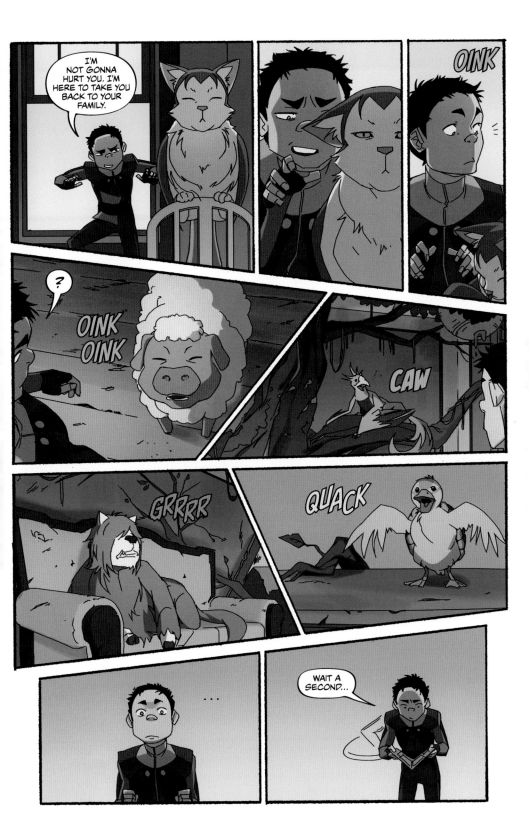

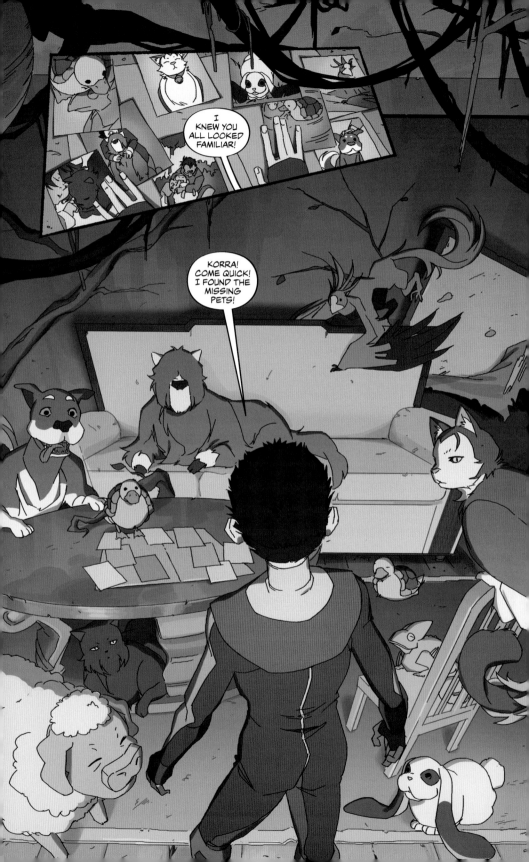

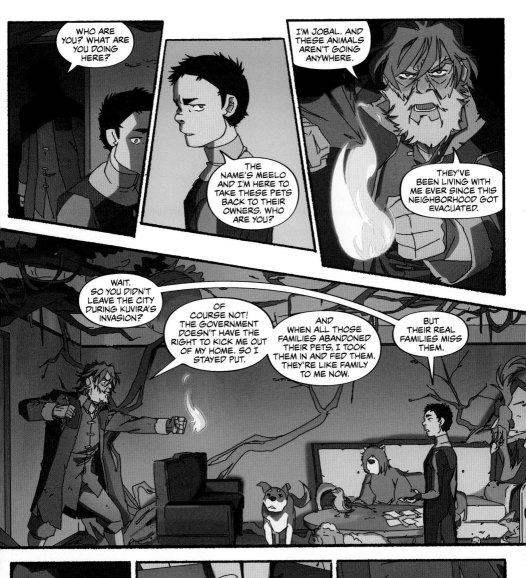

WHO ARE YOU? WHAT ARE YOU DOING HERE?

I'M JOBAL. AND THESE ANIMALS AREN'T GOING ANYWHERE.

THE NAME'S MEELO AND I'M HERE TO TAKE THESE PETS BACK TO THEIR OWNERS. WHO ARE YOU?

THEY'VE BEEN LIVING WITH ME EVER SINCE THIS NEIGHBORHOOD GOT EVACUATED.

WAIT. SO YOU DIDN'T LEAVE THE CITY DURING KUVIRA'S INVASION?

OF COURSE NOT! THE GOVERNMENT DOESN'T HAVE THE RIGHT TO KICK ME OUT OF MY HOME. SO I STAYED PUT.

AND WHEN ALL THOSE FAMILIES ABANDONED THEIR PETS, I TOOK THEM IN AND FED THEM. THEY'RE LIKE FAMILY TO ME NOW.

BUT THEIR REAL FAMILIES MISS THEM.

SEE?

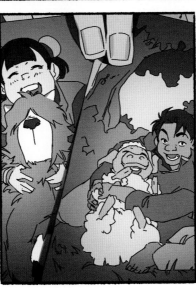

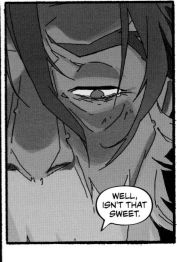

WELL, ISN'T THAT SWEET.

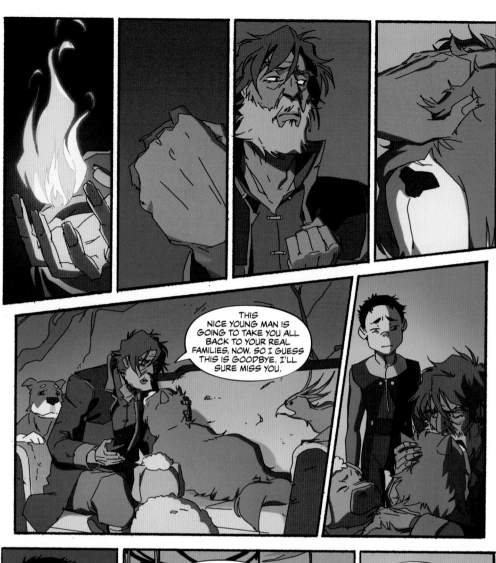

THIS NICE YOUNG MAN IS GOING TO TAKE YOU ALL BACK TO YOUR REAL FAMILIES, NOW. SO I GUESS THIS IS GOODBYE. I'LL SURE MISS YOU.

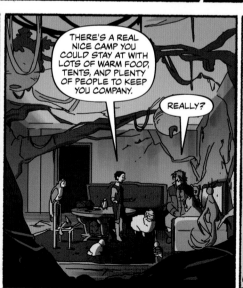

THERE'S A REAL NICE CAMP YOU COULD STAY AT WITH LOTS OF WARM FOOD, TENTS, AND PLENTY OF PEOPLE TO KEEP YOU COMPANY.

REALLY?

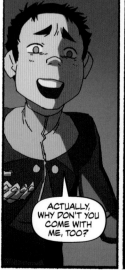

ACTUALLY, WHY DON'T YOU COME WITH ME, TOO?

AND NO OFFENSE, BUT YOU COULD USE A BATH.

TELL ME ABOUT IT!

ALL RIGHT, I'LL TAKE YOU UP ON THAT OFFER. THANK YOU.

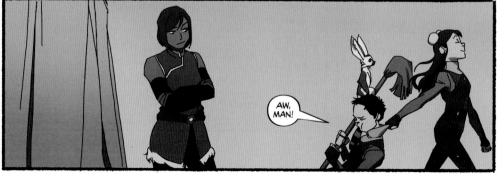

THE END

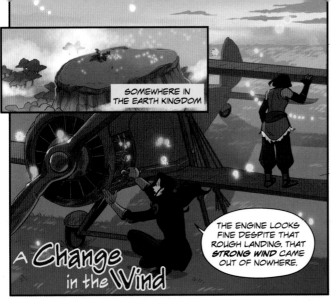

SOMEWHERE IN THE EARTH KINGDOM

A **Change** in the **Wind**

THE ENGINE LOOKS FINE DESPITE THAT ROUGH LANDING. THAT **STRONG WIND** CAME OUT OF NOWHERE.

fuuu

SHEESH, IT SURE IS CHILLY!

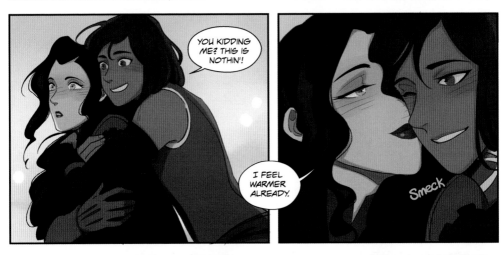

YOU KIDDING ME? THIS IS NOTHIN'!

I FEEL WARMER ALREADY.

Smeck

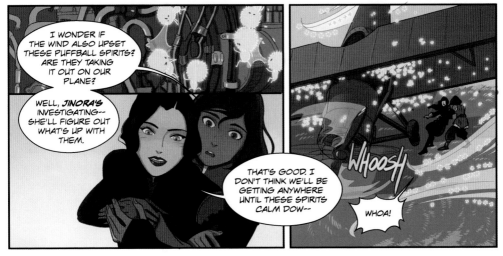

I WONDER IF THE WIND ALSO UPSET THESE PUFFBALL SPIRITS? ARE THEY TAKING IT OUT ON OUR PLANE?

WELL, **JINORA'S** INVESTIGATING-- SHE'LL FIGURE OUT WHAT'S UP WITH THEM.

THAT'S GOOD. I DON'T THINK WE'LL BE GETTING ANYWHERE UNTIL THESE SPIRITS CALM DOW--

WHOOSH

WHOA!

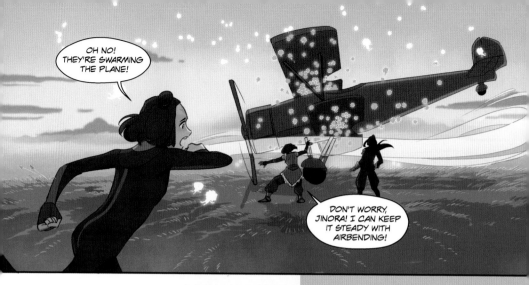

OH NO! THEY'RE SWARMING THE PLANE!

DON'T WORRY, JINORA! I CAN KEEP IT STEADY WITH AIRBENDING!

WHAT'D YOU FIND OUT ABOUT OUR LITTLE FRIENDS?

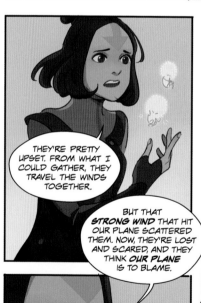

THEY'RE PRETTY UPSET. FROM WHAT I COULD GATHER, THEY TRAVEL THE WINDS TOGETHER.

BUT THAT *STRONG WIND* THAT HIT OUR PLANE SCATTERED THEM. NOW, THEY'RE LOST AND SCARED, AND THEY THINK *OUR PLANE* IS TO BLAME.

I THINK THEY JUST NEED A LITTLE SOOTHING IN THE SPIRIT WORLD BUT--

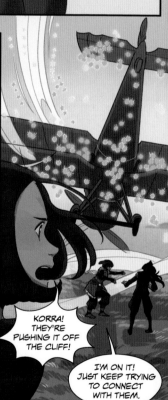

KORRA! THEY'RE PUSHING IT OFF THE CLIFF!

I'M ON IT! JUST KEEP TRYING TO CONNECT WITH THEM.

34

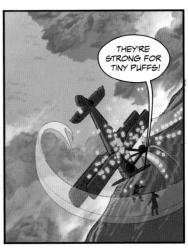

THEY'RE STRONG FOR TINY PUFFS!

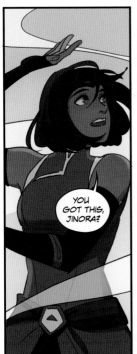

YOU GOT THIS, JINORA?

I'M TRYING, I'M TRYING!

BUT I-- NO MATTER WHAT I--

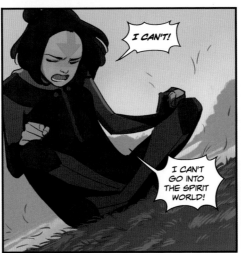

I CAN'T!

I CAN'T GO INTO THE SPIRIT WORLD!

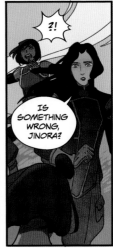

?!

IS SOMETHING WRONG, JINORA?

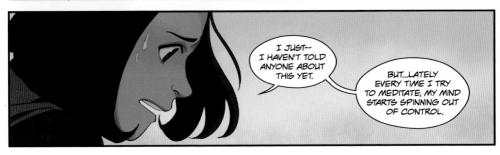

I JUST-- I HAVEN'T TOLD ANYONE ABOUT THIS YET.

BUT...LATELY EVERY TIME I TRY TO MEDITATE, MY MIND STARTS SPINNING OUT OF CONTROL.

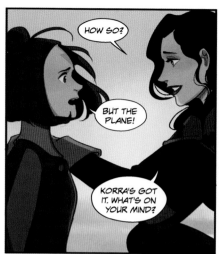

HOW SO?

BUT THE PLANE!

KORRA'S GOT IT. WHAT'S ON YOUR MIND?

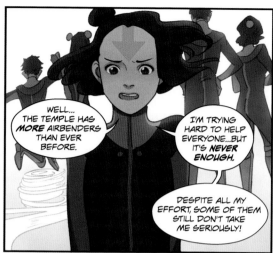

WELL... THE TEMPLE HAS *MORE* AIRBENDERS THAN EVER BEFORE.

I'M TRYING HARD TO HELP EVERYONE...BUT IT'S *NEVER ENOUGH*.

DESPITE ALL MY EFFORT, SOME OF THEM STILL DON'T TAKE ME SERIOUSLY!

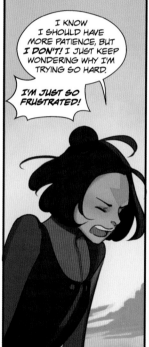

I KNOW I SHOULD HAVE MORE PATIENCE, BUT *I DON'T!* I JUST KEEP WONDERING WHY I'M TRYING SO HARD.

I'M JUST SO FRUSTRATED!

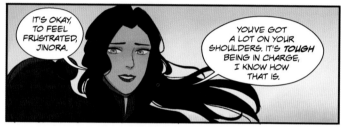

IT'S OKAY, TO FEEL FRUSTRATED, JINORA.

YOU'VE GOT A LOT ON YOUR SHOULDERS. IT'S *TOUGH* BEING IN CHARGE, I KNOW HOW THAT IS.

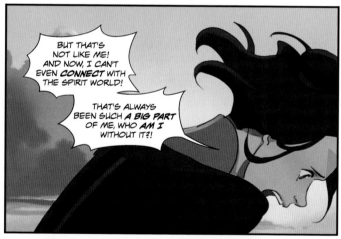

BUT THAT'S NOT LIKE ME! AND NOW, I CAN'T EVEN *CONNECT* WITH THE SPIRIT WORLD!

THAT'S ALWAYS BEEN SUCH *A BIG PART* OF ME, WHO *AM I* WITHOUT IT?!

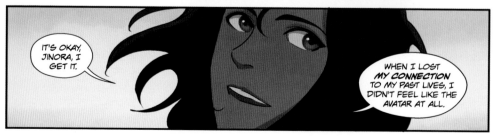

IT'S OKAY, JINORA, I GET IT.

WHEN I LOST *MY CONNECTION* TO MY PAST LIVES, I DIDN'T FEEL LIKE THE AVATAR AT ALL.

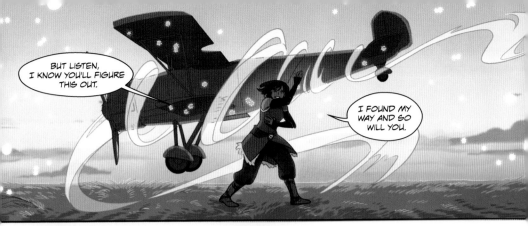

BUT LISTEN, I KNOW YOU'LL FIGURE THIS OUT.

I FOUND MY WAY AND SO WILL YOU.

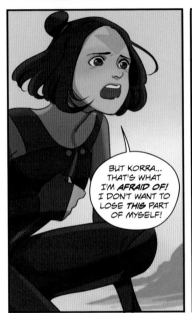

BUT KORRA... THAT'S WHAT I'M *AFRAID OF!* I DON'T WANT TO LOSE *THIS* PART OF MYSELF!

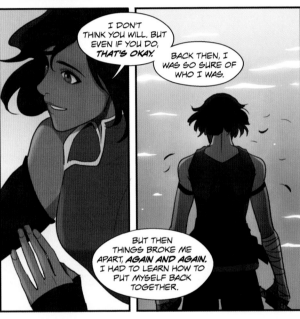

I DON'T THINK YOU WILL. BUT EVEN IF YOU DO, *THAT'S OKAY.*

BACK THEN, I WAS SO SURE OF WHO I WAS.

BUT THEN THINGS BROKE ME APART, *AGAIN AND AGAIN.* I HAD TO LEARN HOW TO PUT MYSELF BACK TOGETHER.

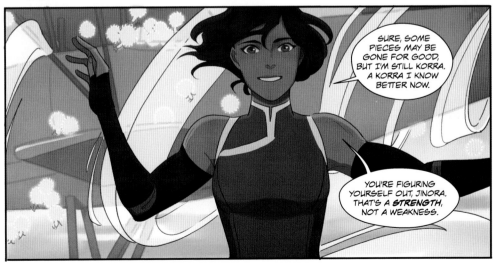

SURE, SOME PIECES MAY BE GONE FOR GOOD, BUT I'M STILL KORRA. A KORRA I KNOW BETTER NOW.

YOU'RE FIGURING YOURSELF OUT, JINORA. THAT'S A *STRENGTH,* NOT A WEAKNESS.

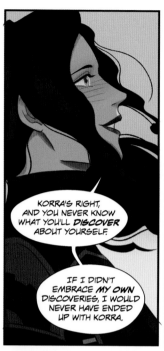

KORRA'S RIGHT, AND YOU NEVER KNOW WHAT YOU'LL *DISCOVER* ABOUT YOURSELF.

IF I DIDN'T EMBRACE *MY OWN* DISCOVERIES, I WOULD NEVER HAVE ENDED UP WITH KORRA.

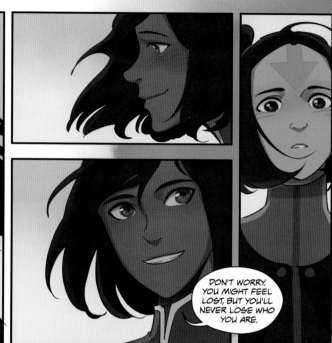

DON'T WORRY. YOU MIGHT FEEL LOST, BUT YOU'LL NEVER LOSE WHO YOU ARE.

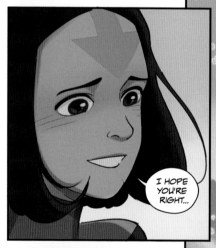

I HOPE YOU'RE RIGHT...

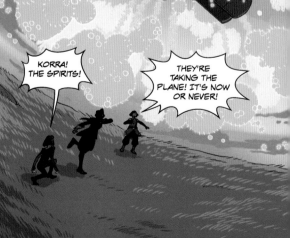

KORRA! THE SPIRITS!

THEY'RE TAKING THE PLANE! IT'S NOW OR NEVER!

GASP

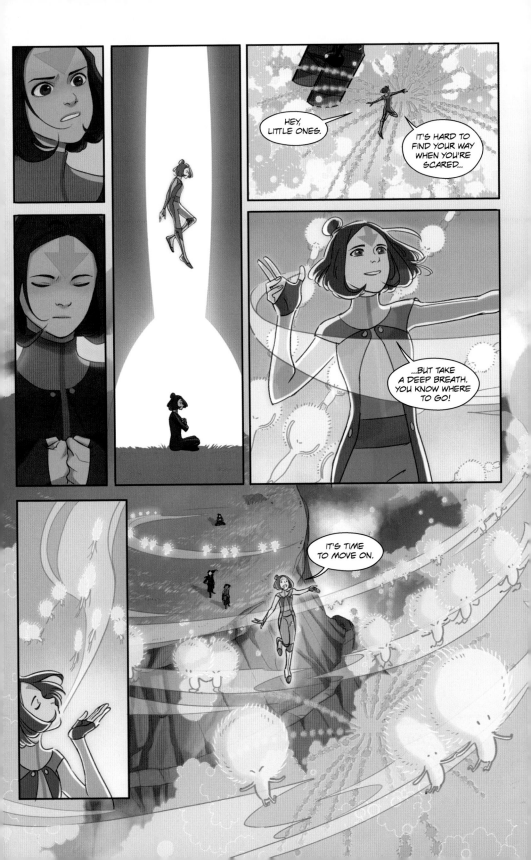

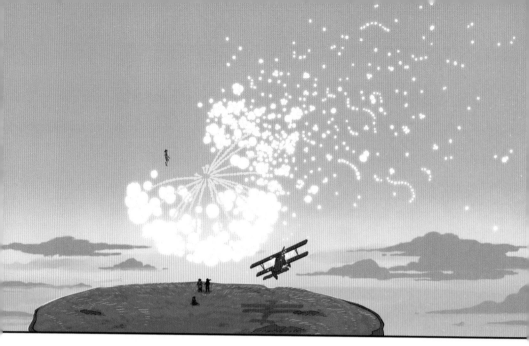

AND SHE THINKS SHE NEEDS *MY* ADVICE.

GOOD TALK. THANKS, YOU TWO!

GOODBYE, LITTLE ONES!

THE END

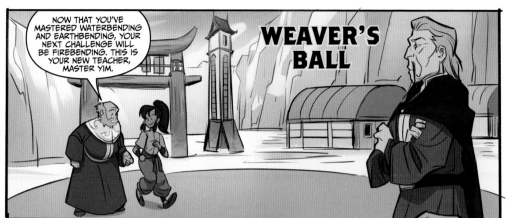

NOW THAT YOU'VE MASTERED WATERBENDING AND EARTHBENDING, YOUR NEXT CHALLENGE WILL BE FIREBENDING. THIS IS YOUR NEW TEACHER, MASTER YIM.

WEAVER'S BALL

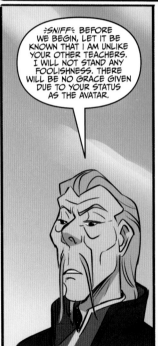

≶SNIFF≷ BEFORE WE BEGIN, LET IT BE KNOWN THAT I AM UNLIKE YOUR OTHER TEACHERS. I WILL NOT STAND ANY FOOLISHNESS. THERE WILL BE NO GRACE GIVEN DUE TO YOUR STATUS AS THE AVATAR.

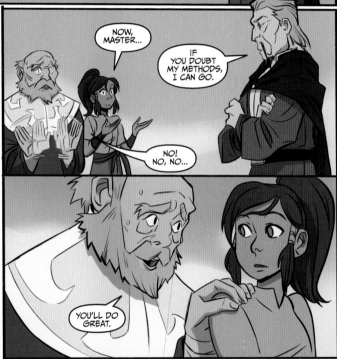

NOW, MASTER...

IF YOU DOUBT MY METHODS, I CAN GO.

NO! NO, NO...

YOU'LL DO GREAT.

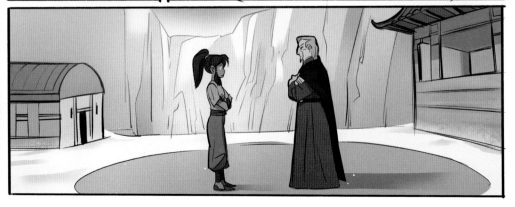

41

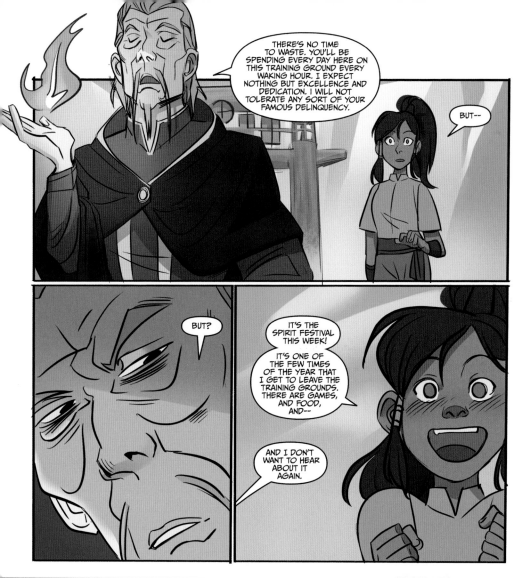

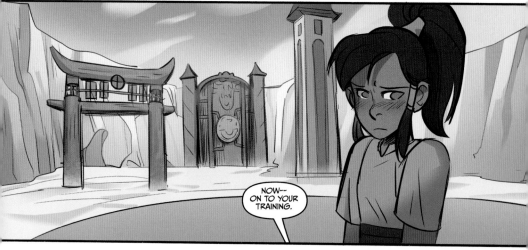

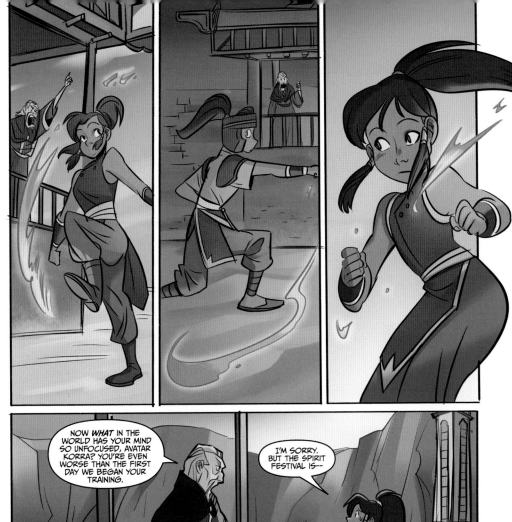

NOW *WHAT* IN THE WORLD HAS YOUR MIND SO UNFOCUSED, AVATAR KORRA? YOU'RE EVEN WORSE THAN THE FIRST DAY WE BEGAN YOUR TRAINING.

I'M SORRY. BUT THE SPIRIT FESTIVAL IS--

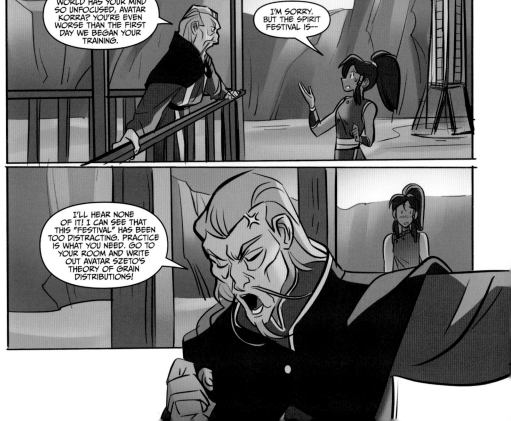

I'LL HEAR NONE OF IT! I CAN SEE THAT THIS "FESTIVAL" HAS BEEN TOO DISTRACTING. PRACTICE IS WHAT YOU NEED. GO TO YOUR ROOM AND WRITE OUT AVATAR SZETO'S THEORY OF GRAIN DISTRIBUTIONS!

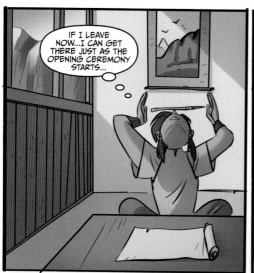

IF I LEAVE NOW...I CAN GET THERE JUST AS THE OPENING CEREMONY STARTS...

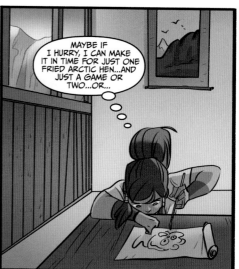

MAYBE IF I HURRY, I CAN MAKE IT IN TIME FOR JUST ONE FRIED ARCTIC HEN...AND JUST A GAME OR TWO...OR...

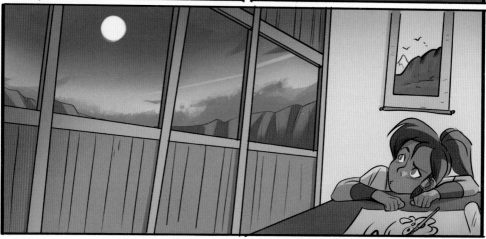

44

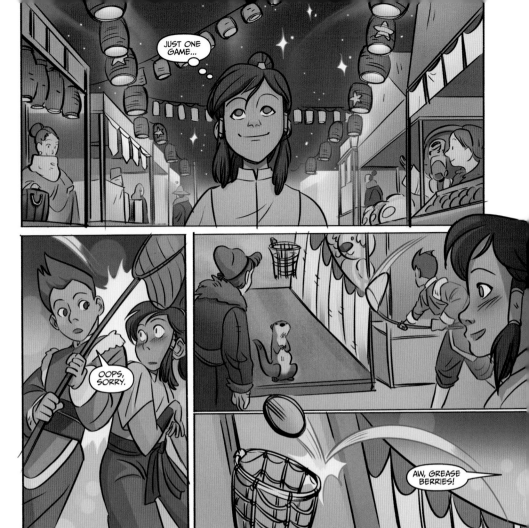

JUST ONE GAME...

OOPS, SORRY.

AW, GREASE BERRIES!

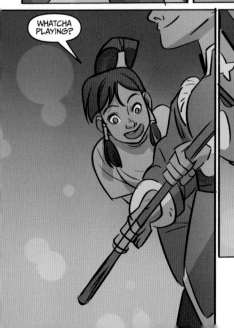

WHATCHA PLAYING?

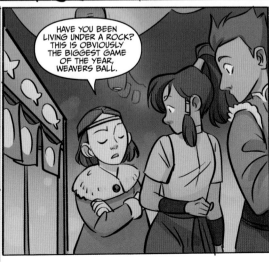

HAVE YOU BEEN LIVING UNDER A ROCK? THIS IS OBVIOUSLY THE BIGGEST GAME OF THE YEAR, WEAVERS BALL.

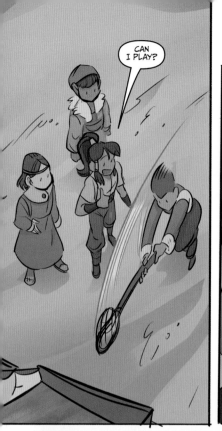

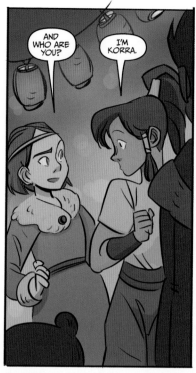

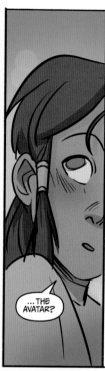

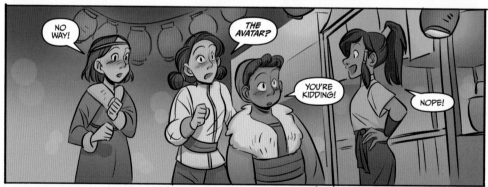

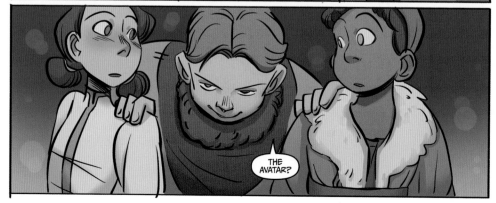

I DON'T BELIEVE IT.

WELL, IT'S TRUE.

PROVE IT.

WELL, I'M TRYING TO LAY LOW...

FALSE ALARM! I THOUGHT SO, JUST ANOTHER LIAR. NOT EVEN A GOOD ONE EITHER. THE AVATAR--HAH!

I'M NOT A LIAR!

SHE'S THE AVATAR, I'M THE AVATAR, WE'RE ALL THE AVATAR!

KNOCK IT OFF!

WHATARYA GONNA DO? FART A FIRE TORNADO?

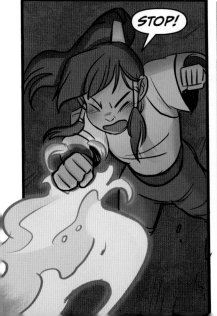

STOP!

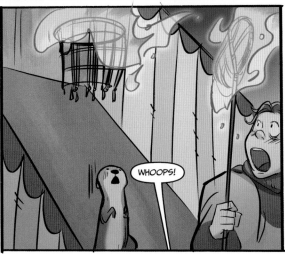

WHOOPS!

47

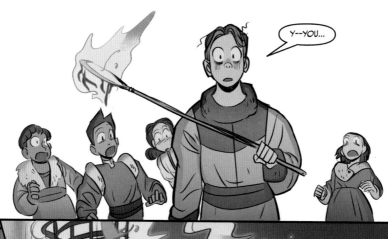

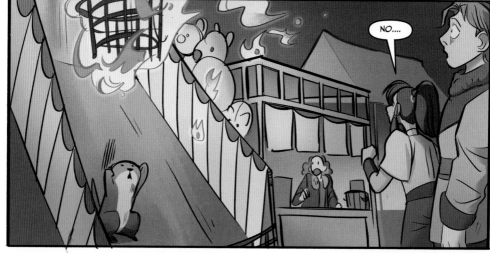

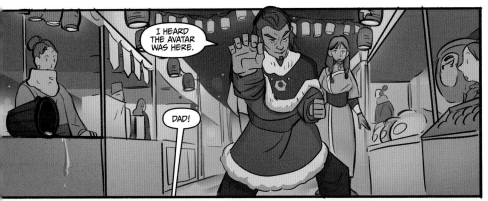

I HEARD THE AVATAR WAS HERE.

DAD!

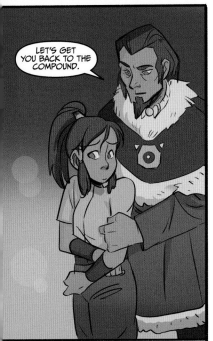

LET'S GET YOU BACK TO THE COMPOUND.

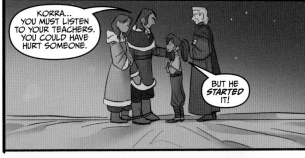

KORRA... YOU MUST LISTEN TO YOUR TEACHERS. YOU COULD HAVE HURT SOMEONE.

BUT HE STARTED IT!

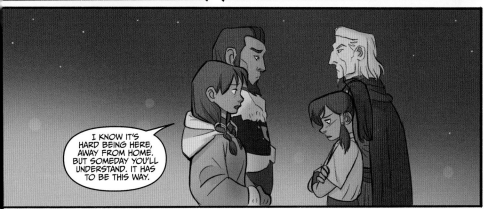

I KNOW IT'S HARD BEING HERE, AWAY FROM HOME. BUT SOMEDAY YOU'LL UNDERSTAND. IT HAS TO BE THIS WAY.

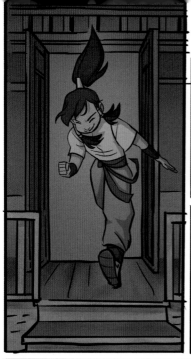

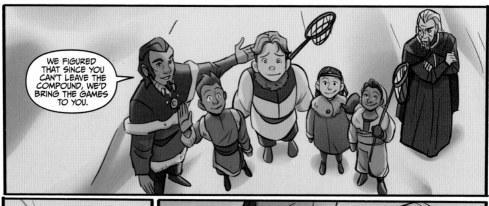

WE FIGURED THAT SINCE YOU CAN'T LEAVE THE COMPOUND, WE'D BRING THE GAMES TO YOU.

YOU MAY BE TRAINING THE AVATAR--

--BUT YOU WON'T BE A KID FOREVER.

THE END

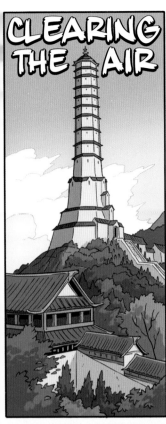

CLEARING THE AIR

BAM

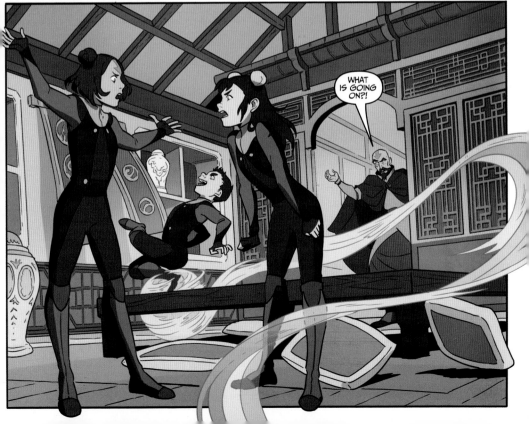

WHAT IS GOING ON?!

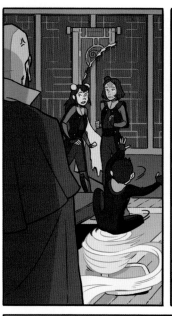

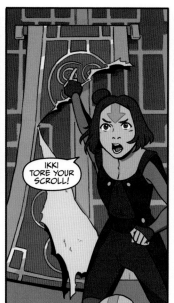

IKKI TORE YOUR SCROLL!

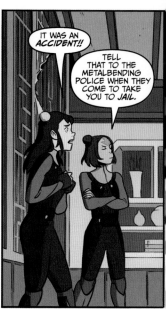

IT WAS AN *ACCIDENT!!*

TELL THAT TO THE METALBENDING POLICE WHEN THEY COME TO TAKE YOU TO *JAIL.*

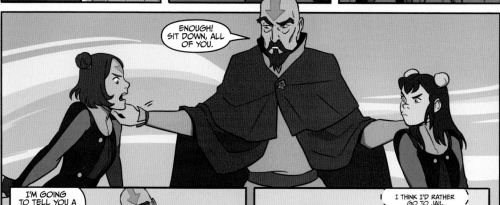

ENOUGH! SIT DOWN, ALL OF YOU.

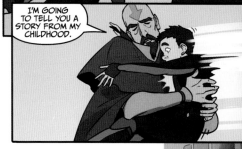

I'M GOING TO TELL YOU A STORY FROM MY CHILDHOOD.

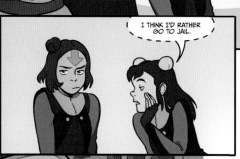

I THINK I'D RATHER GO TO JAIL.

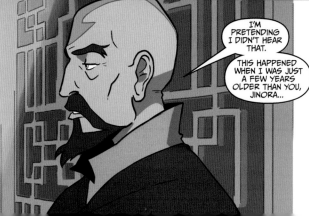

I'M PRETENDING I DIDN'T HEAR THAT.

THIS HAPPENED WHEN I WAS JUST A FEW YEARS OLDER THAN YOU, JINORA...

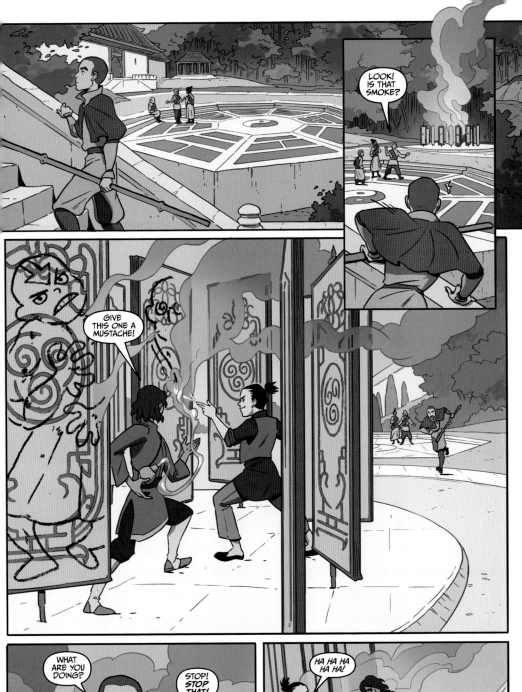

LOOK! IS THAT SMOKE?

GIVE THIS ONE A MUSTACHE!

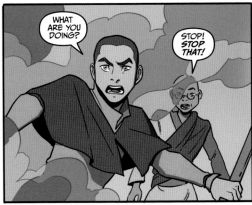

WHAT ARE YOU DOING?

STOP! STOP THAT!

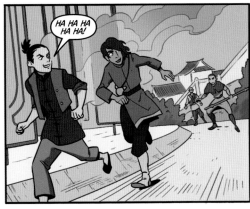

HA HA HA HA HA!

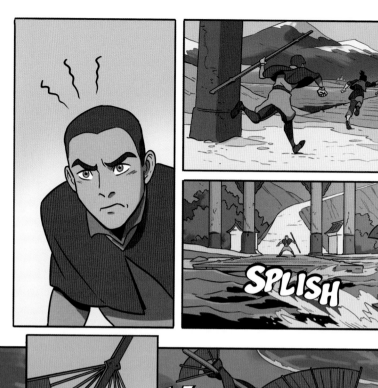

SPLISH

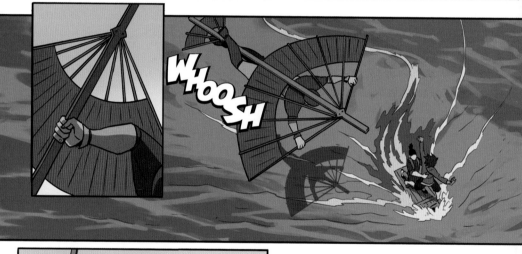

WHOOSH

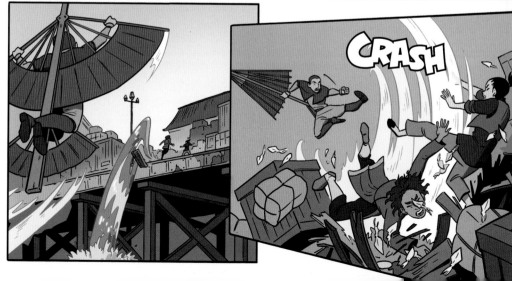

CRASH

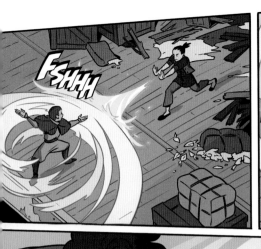

FSHHH

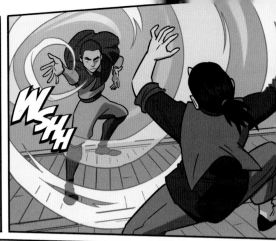

WSHHH

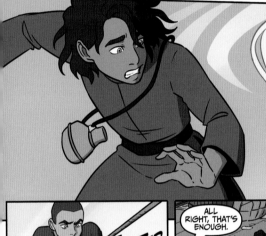

ZZZZIP

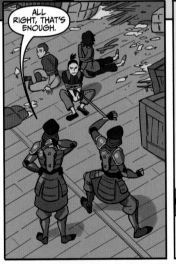

ALL RIGHT, THAT'S ENOUGH.

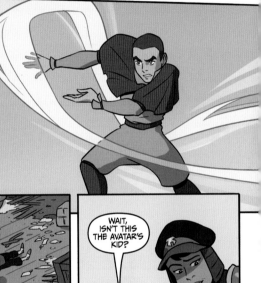

WAIT, ISN'T THIS THE AVATAR'S KID?

CHIEF BEIFONG IS GONNA WANT TO SEE THIS.

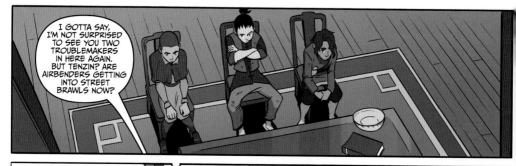

I GOTTA SAY, I'M NOT SURPRISED TO SEE YOU TWO TROUBLEMAKERS IN HERE AGAIN. BUT TENZIN? ARE AIRBENDERS GETTING INTO STREET BRAWLS NOW?

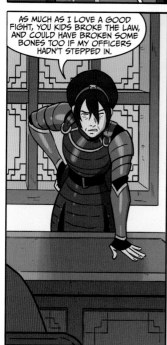

AS MUCH AS I LOVE A GOOD FIGHT, YOU KIDS BROKE THE LAW, AND COULD HAVE BROKEN SOME BONES TOO IF MY OFFICERS HADN'T STEPPED IN.

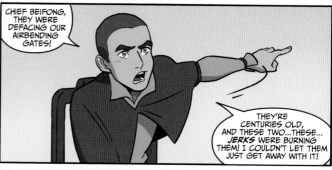

CHIEF BEIFONG, THEY WERE DEFACING OUR AIRBENDING GATES!

THEY'RE CENTURIES OLD, AND THESE TWO...THESE... JERKS WERE BURNING THEM! I COULDN'T LET THEM JUST GET AWAY WITH IT!

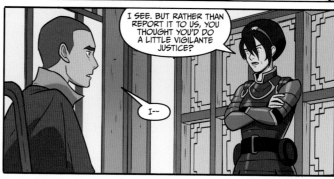

I SEE. BUT RATHER THAN REPORT IT TO US, YOU THOUGHT YOU'D DO A LITTLE VIGILANTE JUSTICE?

I--

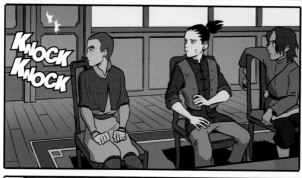

KNOCK KNOCK

AH GOOD, JUST WHAT WE NEED.

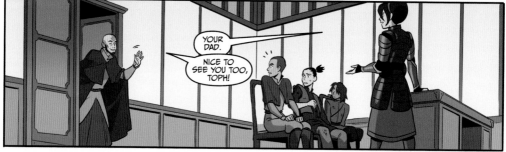

YOUR DAD.

NICE TO SEE YOU TOO, TOPH!

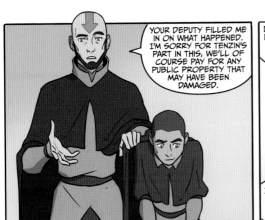

YOUR DEPUTY FILLED ME IN ON WHAT HAPPENED. I'M SORRY FOR TENZIN'S PART IN THIS, WE'LL OF COURSE PAY FOR ANY PUBLIC PROPERTY THAT MAY HAVE BEEN DAMAGED.

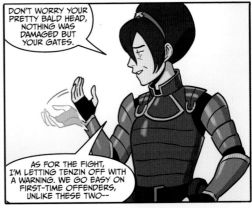

DON'T WORRY YOUR PRETTY BALD HEAD, NOTHING WAS DAMAGED BUT YOUR GATES.

AS FOR THE FIGHT, I'M LETTING TENZIN OFF WITH A WARNING. WE GO EASY ON FIRST-TIME OFFENDERS, UNLIKE THESE TWO--

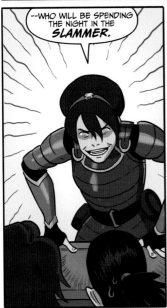

--WHO WILL BE SPENDING THE NIGHT IN THE SLAMMER.

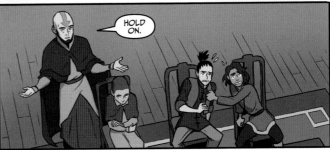

HOLD ON.

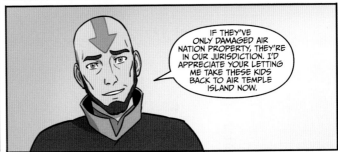

IF THEY'VE ONLY DAMAGED AIR NATION PROPERTY, THEY'RE IN OUR JURISDICTION. I'D APPRECIATE YOUR LETTING ME TAKE THESE KIDS BACK TO AIR TEMPLE ISLAND NOW.

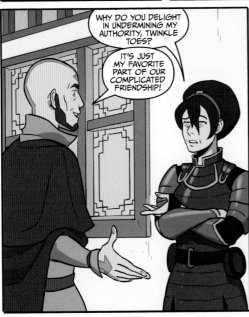

WHY DO YOU DELIGHT IN UNDERMINING MY AUTHORITY, TWINKLE TOES?

IT'S JUST MY FAVORITE PART OF OUR COMPLICATED FRIENDSHIP!

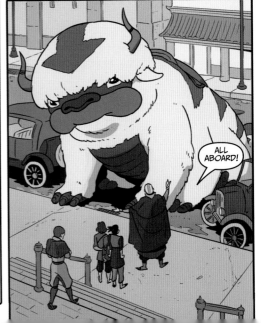

ALL ABOARD!

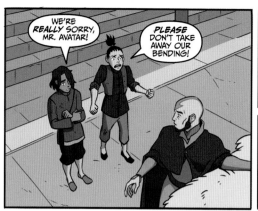

WE'RE *REALLY SORRY*, MR. AVATAR!

PLEASE DON'T TAKE AWAY OUR BENDING!

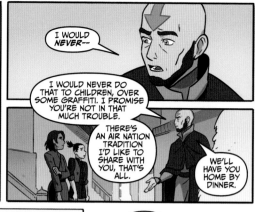

I WOULD *NEVER*--

I WOULD NEVER DO THAT TO CHILDREN, OVER SOME GRAFFITI. I PROMISE YOU'RE NOT IN THAT MUCH TROUBLE.

THERE'S AN AIR NATION TRADITION I'D LIKE TO SHARE WITH YOU, THAT'S ALL.

WE'LL HAVE YOU HOME BY DINNER.

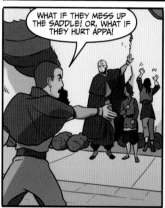

WHAT IF THEY MESS UP THE SADDLE! OR, WHAT IF THEY HURT APPA!

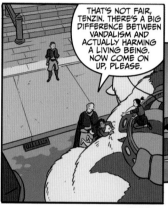

THAT'S NOT FAIR, TENZIN. THERE'S A BIG DIFFERENCE BETWEEN VANDALISM AND ACTUALLY HARMING A LIVING BEING. NOW COME ON UP, PLEASE.

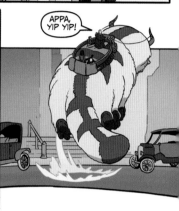

APPA, YIP YIP!

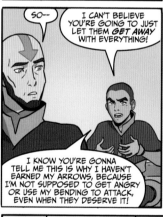

SO--

I CAN'T BELIEVE YOU'RE GOING TO JUST LET THEM *GET AWAY* WITH EVERYTHING!

I KNOW YOU'RE GONNA TELL ME THIS IS WHY I HAVEN'T EARNED MY ARROWS, BECAUSE I'M NOT SUPPOSED TO GET ANGRY OR USE MY BENDING TO ATTACK, EVEN WHEN THEY DESERVE IT!

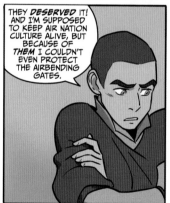

THEY *DESERVED* IT! AND I'M SUPPOSED TO KEEP AIR NATION CULTURE ALIVE, BUT BECAUSE OF *THEM* I COULDN'T EVEN PROTECT THE AIRBENDING GATES.

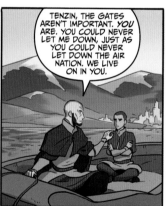

TENZIN, THE GATES AREN'T IMPORTANT. *YOU* ARE. YOU COULD NEVER LET ME DOWN, JUST AS YOU COULD NEVER LET DOWN THE AIR NATION. WE LIVE ON IN YOU.

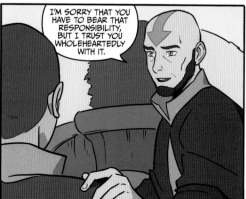

I'M SORRY THAT YOU HAVE TO BEAR THAT RESPONSIBILITY, BUT I TRUST YOU WHOLEHEARTEDLY WITH IT.

AND SO, IF YOU'RE UP FOR IT, I'D LIKE YOU TO LEAD US IN RESOLVING THIS CONFLICT. TRADITIONALLY, THE HEAD MONK WOULD OVERSEE ALL DISPUTES AND HELP BOTH THE OFFENDER AND THE VICTIM COME TO A FAIR RESOLUTION.

BUT I DON'T KNOW WHAT TO DO.

I'LL GUIDE YOU THROUGH IT.

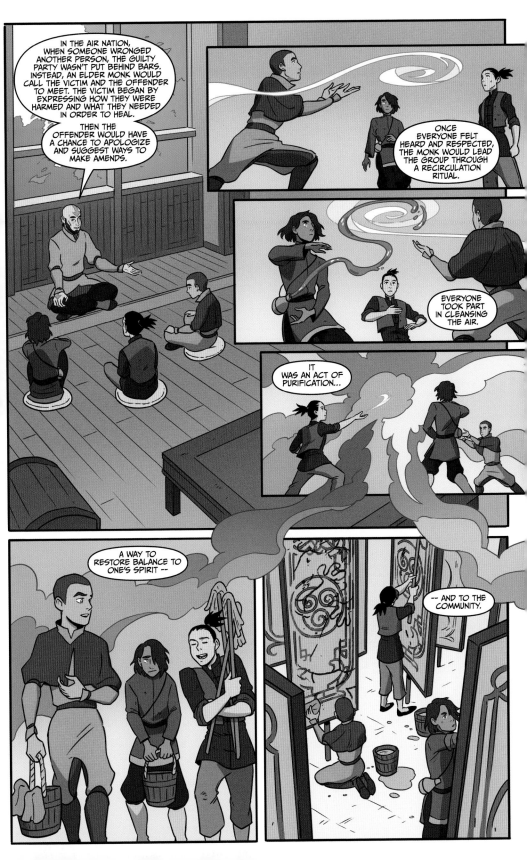

IN THE AIR NATION, WHEN SOMEONE WRONGED ANOTHER PERSON, THE GUILTY PARTY WASN'T PUT BEHIND BARS. INSTEAD, AN ELDER MONK WOULD CALL THE VICTIM AND THE OFFENDER TO MEET. THE VICTIM BEGAN BY EXPRESSING HOW THEY WERE HARMED AND WHAT THEY NEEDED IN ORDER TO HEAL.

THEN THE OFFENDER WOULD HAVE A CHANCE TO APOLOGIZE AND SUGGEST WAYS TO MAKE AMENDS.

ONCE EVERYONE FELT HEARD AND RESPECTED, THE MONK WOULD LEAD THE GROUP THROUGH A RECIRCULATION RITUAL.

EVERYONE TOOK PART IN CLEANSING THE AIR.

IT WAS AN ACT OF PURIFICATION...

A WAY TO RESTORE BALANCE TO ONE'S SPIRIT --

-- AND TO THE COMMUNITY.

I WISH IT WAS ALWAYS THIS EASY TO KEEP THE PEACE.

YES...BUT HE'S YOUNG. LET HIM HAVE THE EASY ONES FOR NOW.

AND LOOK, HE MADE FRIENDS.

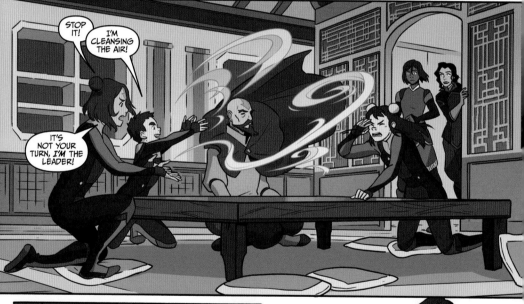

STOP IT! I'M CLEANSING THE AIR!

IT'S NOT YOUR TURN, *I'M* THE LEADER!

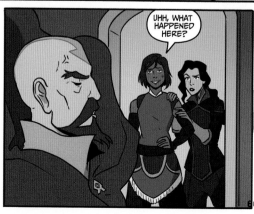

UHH, WHAT HAPPENED HERE?

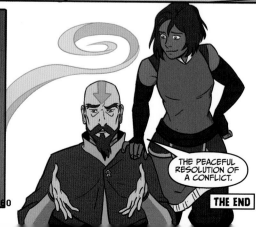

THE PEACEFUL RESOLUTION OF A CONFLICT.

60

THE END

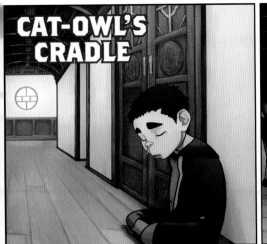

CAT-OWL'S CRADLE

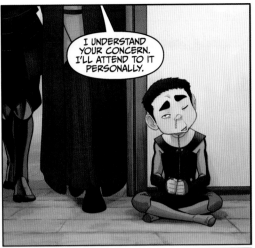

I UNDERSTAND YOUR CONCERN. I'LL ATTEND TO IT PERSONALLY.

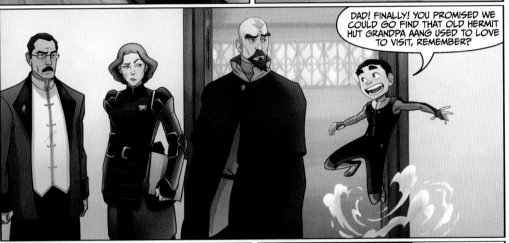

DAD! FINALLY! YOU PROMISED WE COULD GO FIND THAT OLD HERMIT HUT GRANDPA AANG USED TO LOVE TO VISIT, REMEMBER?

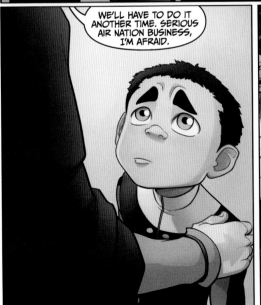

WE'LL HAVE TO DO IT ANOTHER TIME. SERIOUS AIR NATION BUSINESS, I'M AFRAID.

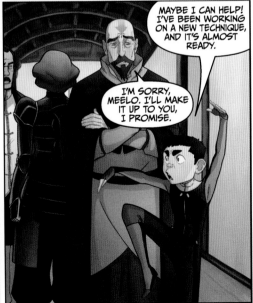

MAYBE I CAN HELP! I'VE BEEN WORKING ON A NEW TECHNIQUE, AND IT'S ALMOST READY.

I'M SORRY, MEELO. I'LL MAKE IT UP TO YOU, I PROMISE.

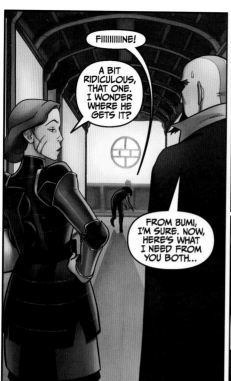

FIIIIIIIINE!

A BIT RIDICULOUS, THAT ONE. I WONDER WHERE HE GETS IT?

FROM BUMI, I'M SURE. NOW, HERE'S WHAT I NEED FROM YOU BOTH...

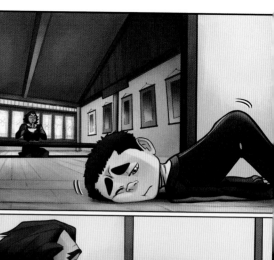

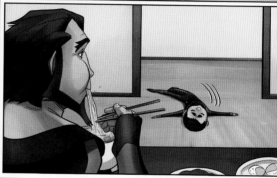

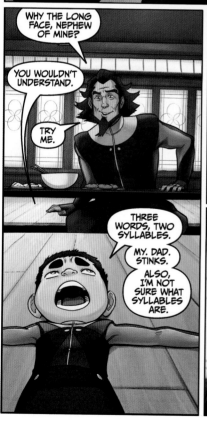

WHY THE LONG FACE, NEPHEW OF MINE?

YOU WOULDN'T UNDERSTAND.

TRY ME.

THREE WORDS, TWO SYLLABLES.

MY. DAD. STINKS.

ALSO, I'M NOT SURE WHAT SYLLABLES ARE.

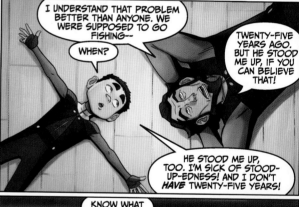

I UNDERSTAND THAT PROBLEM BETTER THAN ANYONE. WE WERE SUPPOSED TO GO FISHING--

WHEN?

TWENTY-FIVE YEARS AGO. BUT HE STOOD ME UP, IF YOU CAN BELIEVE THAT!

HE STOOD ME UP, TOO. I'M SICK OF STOOD-UP-EDNESS! AND I DON'T *HAVE* TWENTY-FIVE YEARS!

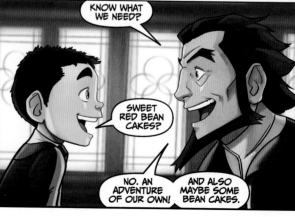

KNOW WHAT WE NEED?

SWEET RED BEAN CAKES?

NO. AN ADVENTURE OF OUR OWN!

AND ALSO MAYBE SOME BEAN CAKES.

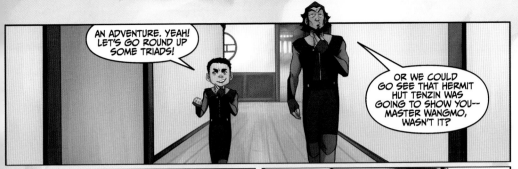

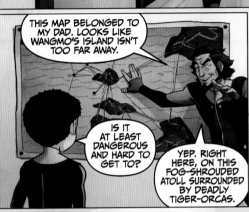

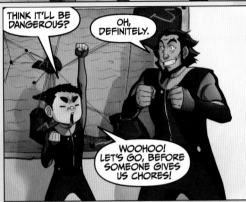

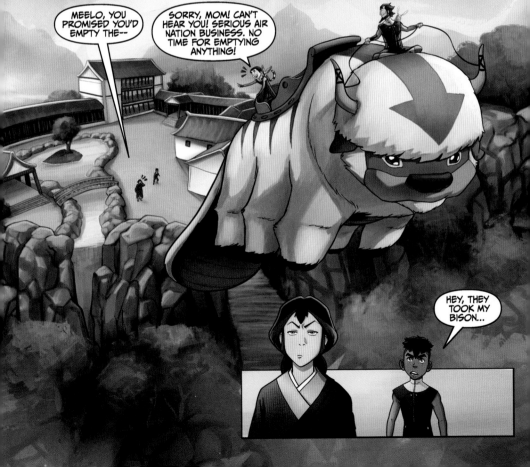

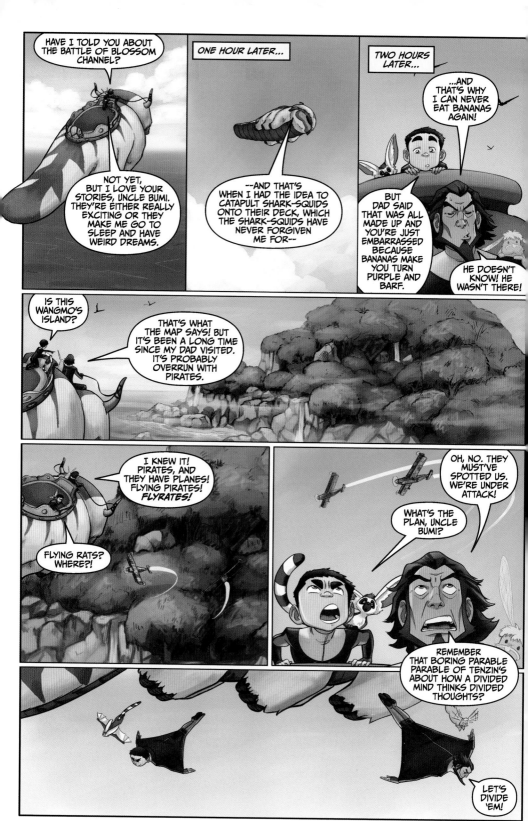

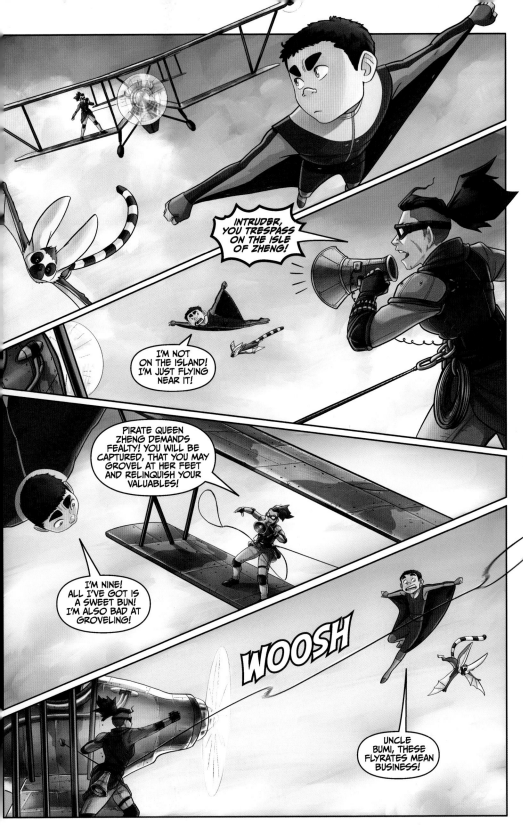

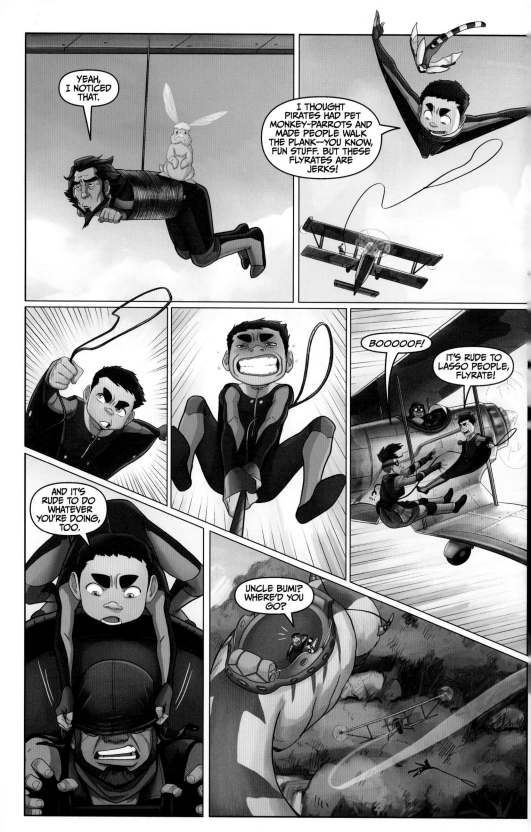

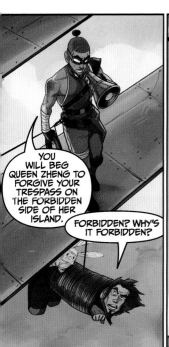

YOU WILL BEG QUEEN ZHENG TO FORGIVE YOUR TRESPASS ON THE FORBIDDEN SIDE OF HER ISLAND.

FORBIDDEN? WHY'S IT FORBIDDEN?

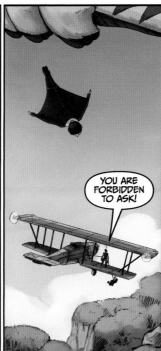

YOU ARE FORBIDDEN TO ASK!

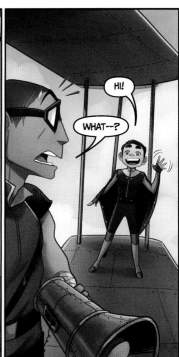

HI!

WHAT--?

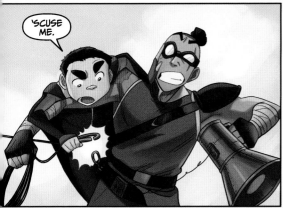

'SCUSE ME.

THE PIRATE QUEEN SHALL HEAR ABOUT THIIIIIS!!

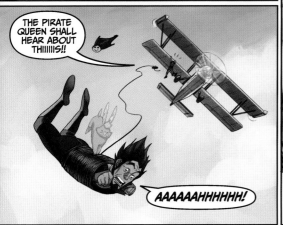

AAAAAAHHHHHH!

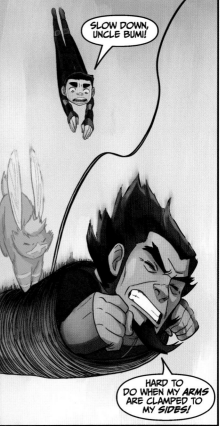

SLOW DOWN, UNCLE BUMI!

HARD TO DO WHEN MY ARMS ARE CLAMPED TO MY SIDES!

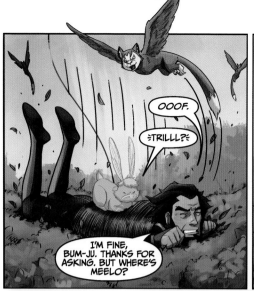

OOOF.

≈TRILLL?≈

I'M FINE, BUM-JU. THANKS FOR ASKING. BUT WHERE'S MEELO?

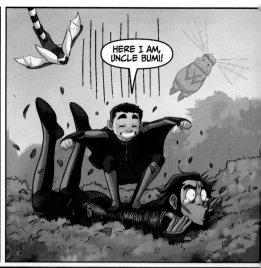

HERE I AM, UNCLE BUMI!

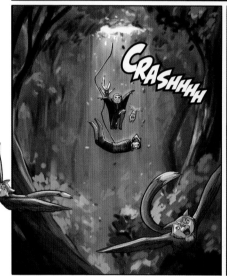

CRASHHHH

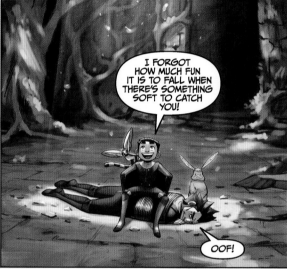

I FORGOT HOW MUCH FUN IT IS TO FALL WHEN THERE'S SOMETHING SOFT TO CATCH YOU!

OOF!

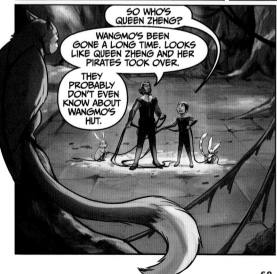

SO WHO'S QUEEN ZHENG?

WANGMO'S BEEN GONE A LONG TIME. LOOKS LIKE QUEEN ZHENG AND HER PIRATES TOOK OVER.

THEY PROBABLY DON'T EVEN KNOW ABOUT WANGMO'S HUT.

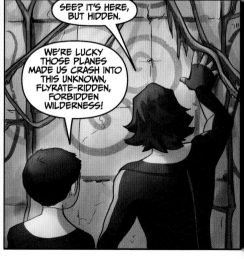

SEE? IT'S HERE, BUT HIDDEN.

WE'RE LUCKY THOSE PLANES MADE US CRASH INTO THIS UNKNOWN, FLYRATE-RIDDEN, FORBIDDEN WILDERNESS!

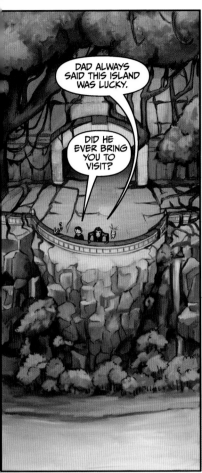

DAD ALWAYS SAID THIS ISLAND WAS LUCKY.

DID HE EVER BRING YOU TO VISIT?

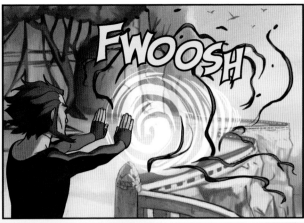

FWOOSH

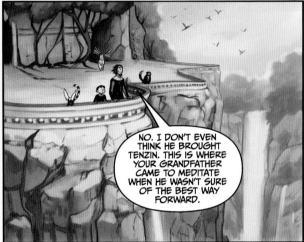

NO. I DON'T EVEN THINK HE BROUGHT TENZIN. THIS IS WHERE YOUR GRANDFATHER CAME TO MEDITATE WHEN HE WASN'T SURE OF THE BEST WAY FORWARD.

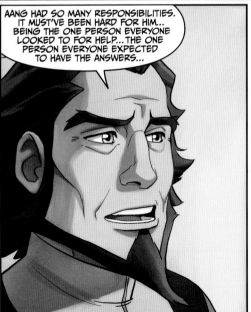

AANG HAD SO MANY RESPONSIBILITIES. IT MUST'VE BEEN HARD FOR HIM... BEING THE ONE PERSON EVERYONE LOOKED TO FOR HELP... THE ONE PERSON EVERYONE EXPECTED TO HAVE THE ANSWERS...

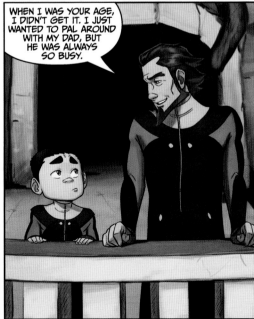

WHEN I WAS YOUR AGE, I DIDN'T GET IT. I JUST WANTED TO PAL AROUND WITH MY DAD, BUT HE WAS ALWAYS SO BUSY.

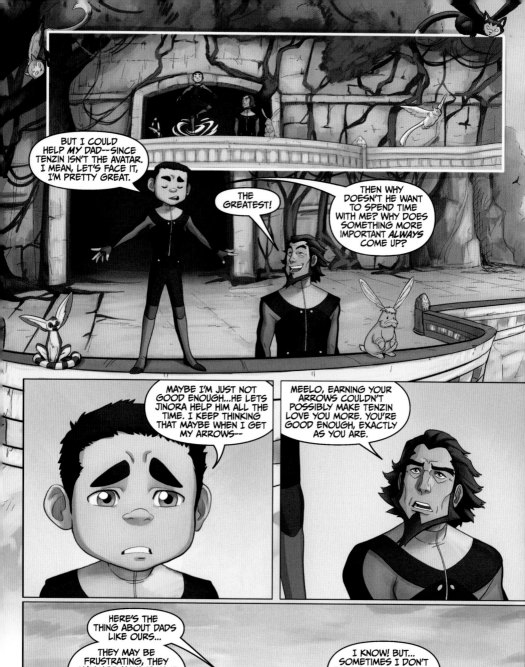

BUT I COULD HELP *MY* DAD--SINCE TENZIN ISN'T THE AVATAR. I MEAN, LET'S FACE IT, I'M PRETTY GREAT.

THE GREATEST!

THEN WHY DOESN'T HE WANT TO SPEND TIME WITH ME? WHY DOES SOMETHING MORE IMPORTANT *ALWAYS* COME UP?

MAYBE I'M JUST NOT GOOD ENOUGH...HE LETS JINORA HELP HIM ALL THE TIME. I KEEP THINKING THAT MAYBE WHEN I GET MY ARROWS--

MEELO, EARNING YOUR ARROWS COULDN'T POSSIBLY MAKE TENZIN LOVE YOU MORE. YOU'RE GOOD ENOUGH, EXACTLY AS YOU ARE.

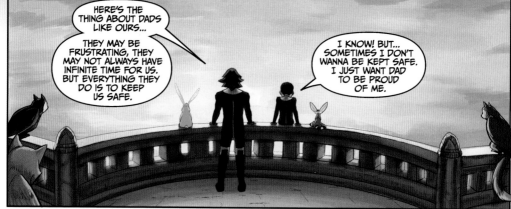

HERE'S THE THING ABOUT DADS LIKE OURS...

THEY MAY BE FRUSTRATING, THEY MAY NOT ALWAYS HAVE INFINITE TIME FOR US. BUT EVERYTHING THEY DO IS TO KEEP US SAFE.

I KNOW! BUT... SOMETIMES I DON'T WANNA BE KEPT SAFE. I JUST WANT DAD TO BE PROUD OF ME.

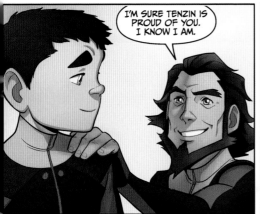

I'M SURE TENZIN IS PROUD OF YOU. I KNOW I AM.

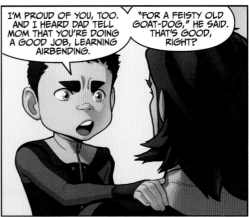

I'M PROUD OF YOU, TOO. AND I HEARD DAD TELL MOM THAT YOU'RE DOING A GOOD JOB, LEARNING AIRBENDING.

"FOR A FEISTY OLD GOAT-DOG," HE SAID. THAT'S GOOD, RIGHT?

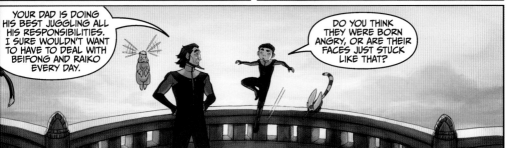

YOUR DAD IS DOING HIS BEST JUGGLING ALL HIS RESPONSIBILITIES. I SURE WOULDN'T WANT TO HAVE TO DEAL WITH BEIFONG AND RAIKO EVERY DAY.

DO YOU THINK THEY WERE BORN ANGRY, OR ARE THEIR FACES JUST STUCK LIKE THAT?

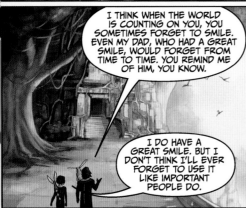

I THINK WHEN THE WORLD IS COUNTING ON YOU, YOU SOMETIMES FORGET TO SMILE. EVEN MY DAD, WHO HAD A GREAT SMILE, WOULD FORGET FROM TIME TO TIME. YOU REMIND ME OF HIM, YOU KNOW.

I DO HAVE A GREAT SMILE. BUT I DON'T THINK I'LL EVER FORGET TO USE IT LIKE IMPORTANT PEOPLE DO.

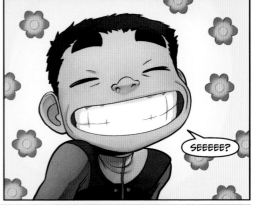

SEEEEE?

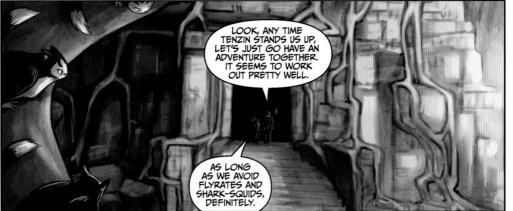

LOOK, ANY TIME TENZIN STANDS US UP, LET'S JUST GO HAVE AN ADVENTURE TOGETHER. IT SEEMS TO WORK OUT PRETTY WELL.

AS LONG AS WE AVOID FLYRATES AND SHARK-SQUIDS, DEFINITELY.

71

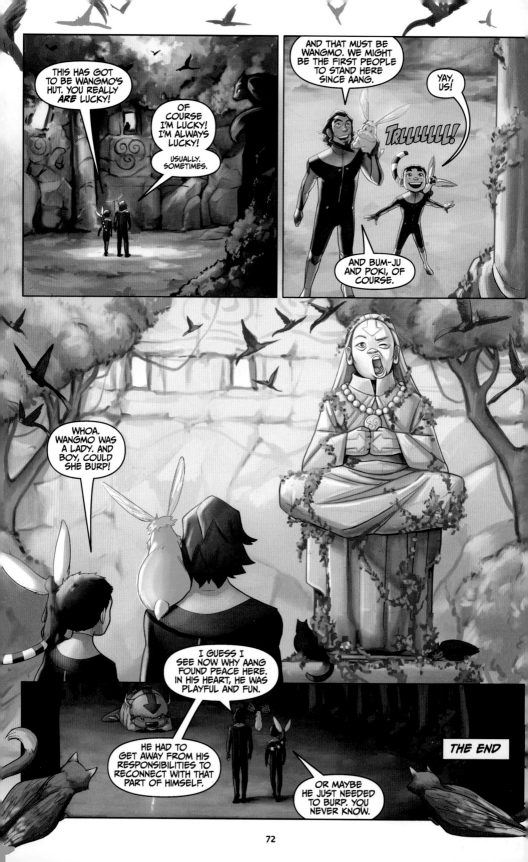

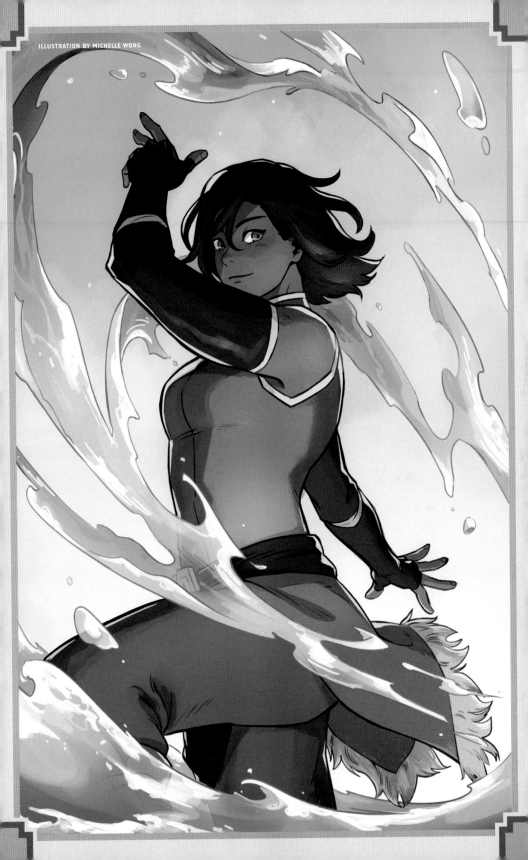

ILLUSTRATION BY MICHELLE WONG

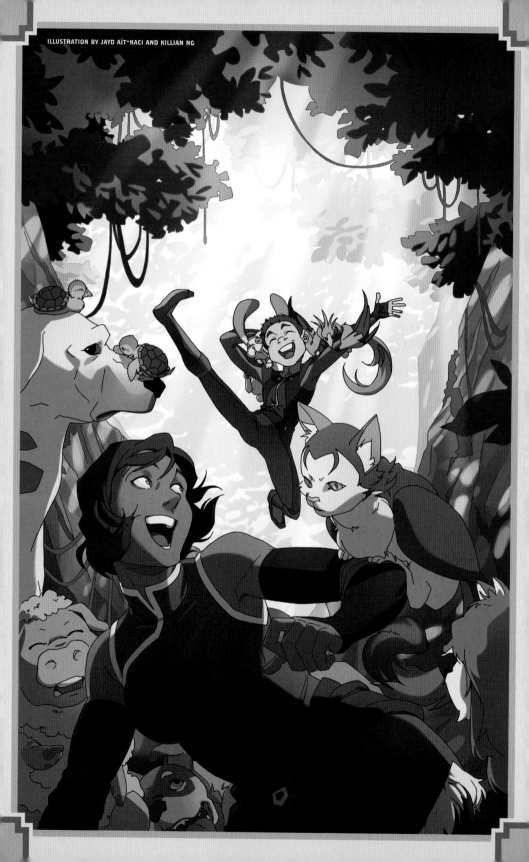

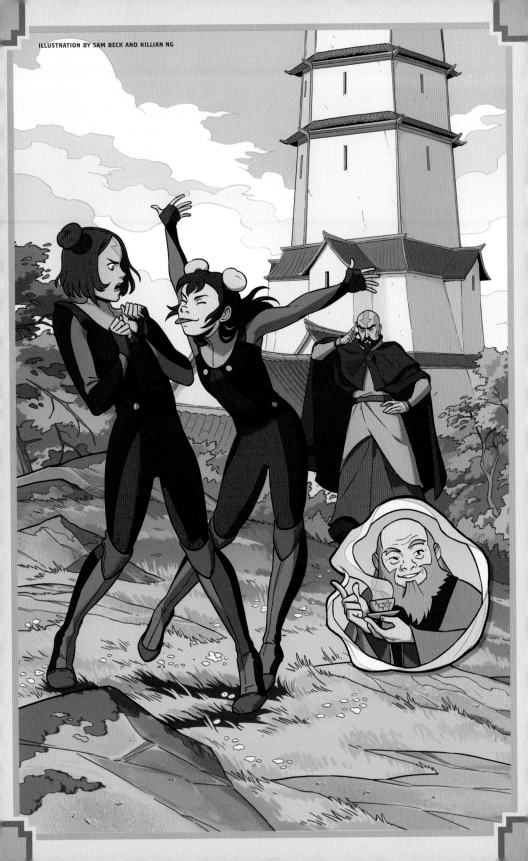

ILLUSTRATION BY SAM BECK AND KILLIAN NG

nickelodeon™

THE LEGEND OF KORRA™

PATTERNS IN TIME

Sketchbook

Notes by editor RACHEL ROBERTS

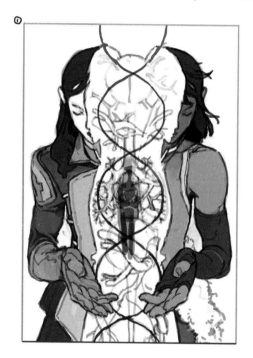

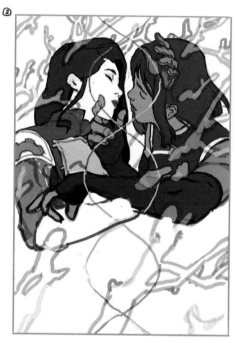

Above: *It was an honor to work with brilliant artist Sachin Teng for this cover. Every time I've worked with Sachin in the past, I've always been blown away by her copious use of visual metaphor and deep symbolism, as well as the extensive thought that goes into the compositions. For this first cover sketch, she noted that "everything is being split apart while simultaneously being held together by a common soul and a common heart, literally . . . the Republic City Spirit Portal, the double helix in the beam of light, and all the spirit vines and foliage of the Spirit Wilds . . . in the shape of the human vascular system, which is being shared by two split halves, one of Korra and one of Asami."*

In the unused second sketch, "Korra and Asami [are] almost . . . Spirits themselves, their bodies passing through each other" with the vines and other objects providing "an allegory for humans and Spirits no longer having boundaries between each other and learning to coexist and cohabitate."

Opposite: *A selection of Sam Beck's layouts and final inks for "Skyscrapers." Isn't little Asami adorable? Since Yasuko doesn't have much screen or page time otherwise, it was really special to be able to bring this moment between mother and daughter to life with this story.*

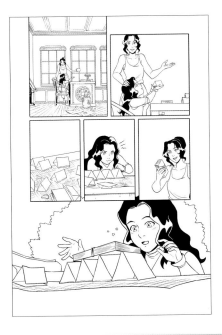

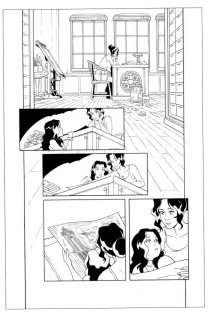

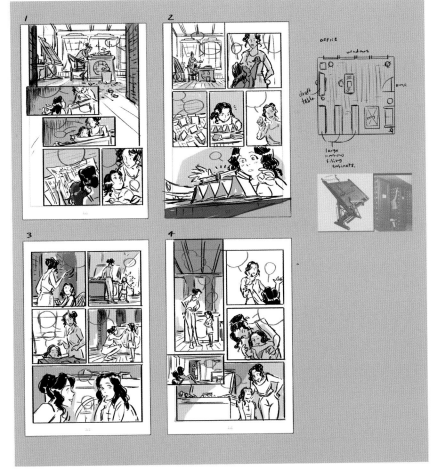

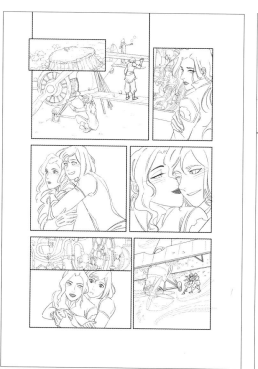

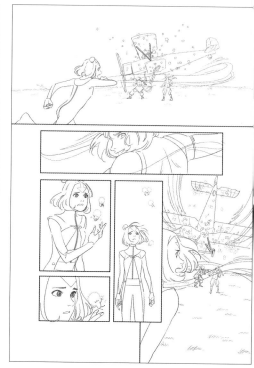

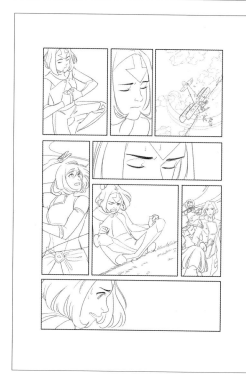

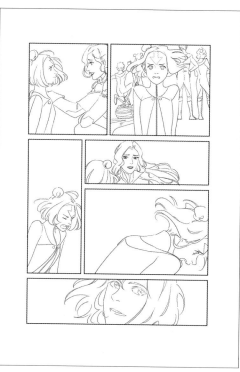

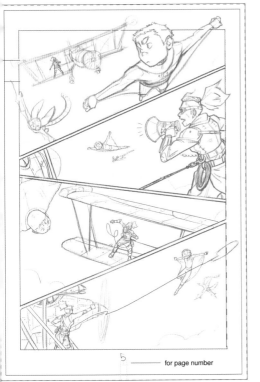

5 ——— for page number

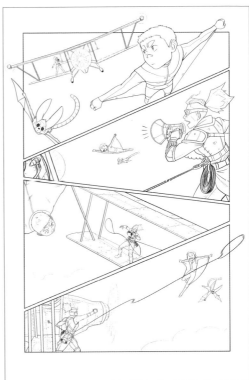

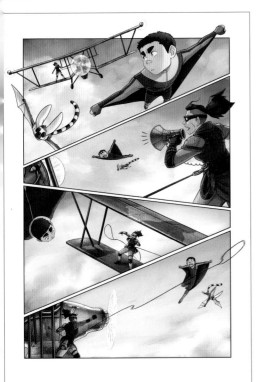

Opposite: *A selection of inks from Jen Xu and K. Rhodes' story "A Change in the Wind." Their elegant, delicate line work was a boon to this emotional story. Jinora's connection to the Spirit World has always been an important aspect of her identity, and this was a great opportunity for Korra and Asami to mentor her.*

Above: *Pencils, inks, and final colors for page 65 by Alexandria Monik for "Cat-Owl's Cradle." Alex's confident inking and incredible ability to match the animated series' character models is second to none. Each of Meelo's expressions in this story is hilarious and adorable. Yes, even the ones where he has a booger.*